Interpreting
SARGENT

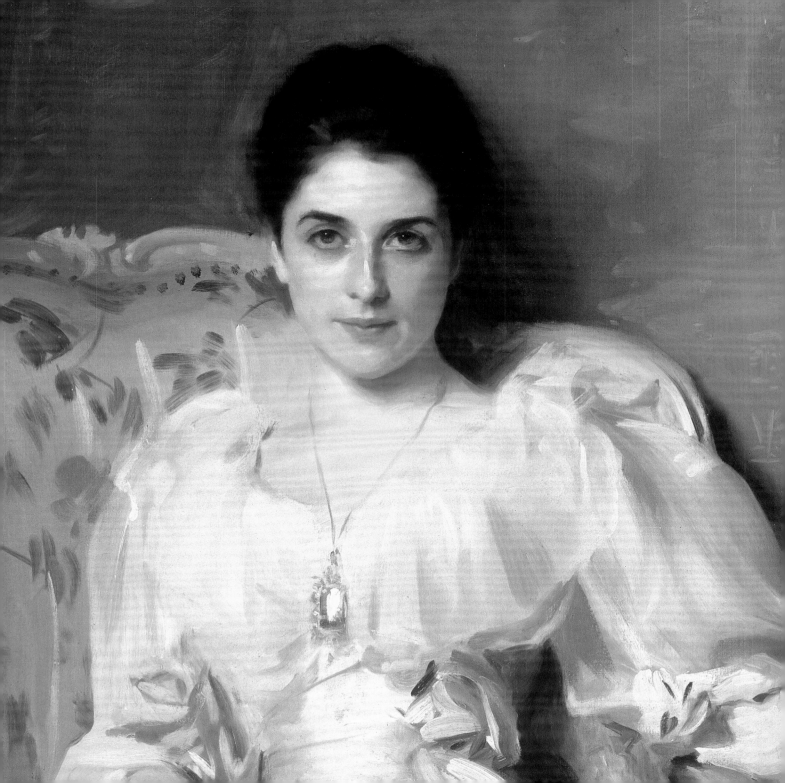

Interpreting
SARGENT

Elizabeth Prettejohn

Tate Gallery Publishing

For the art historian to whom I owe most,
Joan Larson Esch

Acknowledgements

I am grateful to Kathleen Adler, John House, Elaine
Kilmurray, and Richard Ormond for their comments, and
to Sarah Derry for editing of great ingenuity. I owe special
thanks to Neil Levine, supervisor of my undergraduate
thesis on the Boston Public Library many years ago; and to
Trevor Fairbrother, whose work on Sargent has stimulated
my interest ever since. As always, Charles Martindale has
given the greatest encouragement along with the most
rigorous criticism.

front cover: *Paul Helleu Sketching with his Wife* 1889
(detail of fig.40)

frontispiece: *Lady Agnew of Lochnaw* 1892 (detail of fig.23)

back cover: *Ena and Betty, Daughters of Asher and
Mrs Wertheimer* 1901 (fig.60)

Published by order of the Trustees of the Tate Gallery
by Tate Gallery Publishing Ltd, Millbank,
London SW1P 4RG

© 1998 Elizabeth Prettejohn

ISBN 1 85437 249 1

A catalogue record for this publication is available
from the British Library

Designed and typeset by Caroline Johnston
Printed in Great Britain by Balding + Mansell, Norwich

Sponsor's Foreword

Morgan Stanley Dean Witter is very pleased to be support-
ing the Tate Gallery by sponsoring the *John Singer Sargent*
exhibition, the first large-scale retrospective of the artist's
work since the memorial exhibitions of 1925 and 1926.
Like Sargent, Morgan Stanley Dean Witter is of American
parentage with deep roots in Europe. John Singer Sargent is
now increasingly recognised as one of the most important
artists of his time and the exhibition is expected to attract
widespread critical and public interest.

As a global investment banking firm, Morgan Stanley
Dean Witter supports an extensive programme of cultural
and educational projects, believing firmly in the benefits
these bring to the communities in which we work. In this
instance, as part of our exhibition sponsorship, we are
working closely with the Tate on its educational and out-
reach programme. Part of this programme aims to engage
with the literacy problems faced by many primary and
secondary schools and will have a special focus on schools
in London's East End, where we have our European head-
quarters at Canary Wharf.

We congratulate the Tate Gallery on mounting this
historically interesting and striking exhibition, and we hope
that our sponsorship will enable many people to come and
enjoy the beautiful work of John Singer Sargent.

Sir David Walker
Chairman of Morgan Stanley International Inc.

Exhibition sponsored by
MORGAN STANLEY DEAN WITTER

Contents

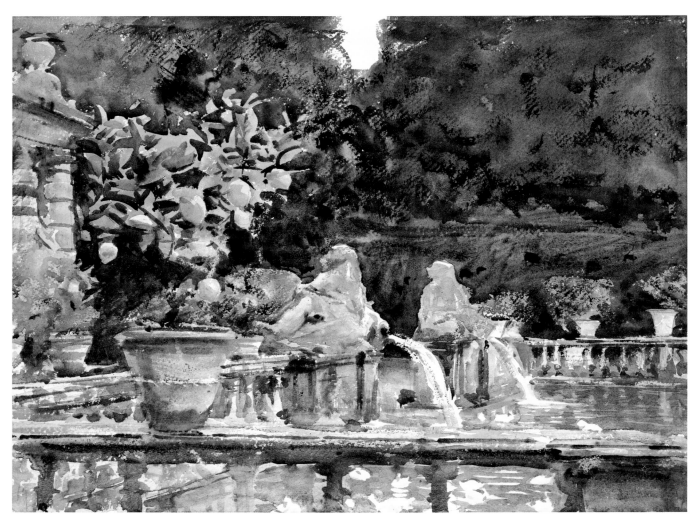

Villa di Marlia: A Fountain 1910
watercolour on paper 40.6 × 52.7 (16 × 20¾)
Museum of Fine Arts, Boston. Hayden Collection.
Purchased, Charles Henry Hayden Fund, 1912

Introduction: On the Brink of Modernity

John Singer Sargent (1856–1925) poses problems for interpretation. He was among America's most famous citizens in 1900, yet his subsequent reputation has been equivocal. Like his compatriots James McNeill Whistler and Mary Cassatt, Sargent was trained in Paris and thus had every opportunity to participate in the experiments of the French avant-garde, but unlike them he has never been enrolled in the avant-garde canon. Art historians have therefore seen his style as a compromise, hovering somewhere between traditionalism and modernism, yet committed to neither. But do the conventional art-historical categories impose too rigid a polarity? As this book will argue, we should interpret Sargent's art as an approach to the modern that offers a significant alternative to the avant-garde 'mainstream'. Indeed, the study of Sargent's art can help to break the art-historical stalemate between traditionalism and modernism.

Sargent's celebrity rested on a portrait practice begun in Paris, but crystallising after his move to London in 1886. We do not despise Van Dyck or Velázquez for painting the royalty and aristocracy of their ages, but Sargent's reputation as the favourite painter of the British imperial elite has proved more difficult to countenance – he is blamed for celebrating a status quo that ought rather to be censured. However, we should look more closely at Sargent's portraits. The period of his heyday was one of social change that affected the upper classes as radically as it did the lower social strata. This book will argue that, far from endorsing a status quo, Sargent's portraits dramatised the precarious glamour of an upper class in rapid transition.

Many of Sargent's sitters were American, not European. Indeed, the class he painted comprised not simply an outmoded aristocracy but a new, international super-class, increasingly dominated by American wealth, and nothing if not 'modern'. Sargent's practice of updating European grand-manner portraiture has been attacked as inappropriate for modern America; the monumental mural paintings he executed for America's new public buildings have been similarly censured for their dependence on European conventions. But should we require American art to pursue an isolationist policy? Sargent's work can be seen instead as creating links between the European past and an America envisaging a future of international scope.

The splendour and aplomb of Sargent's painting technique struck his contemporaries with awe. Later writers have accused him of excessive facility or superficiality, yet the apparent ease with which Sargent achieved his most flamboyant effects should not blind us to their sophistication. The myth of Sargent's superficiality has tended to produce superficial answers to the major questions about Sargent's art. But we should not permit his technical facility to dictate facile interpretations of his painting. Instead, this book aims at interpretive opulence to respond to the opulence, not so much of Sargent's sitters, as of his imaginative and technical contribution to modern art.

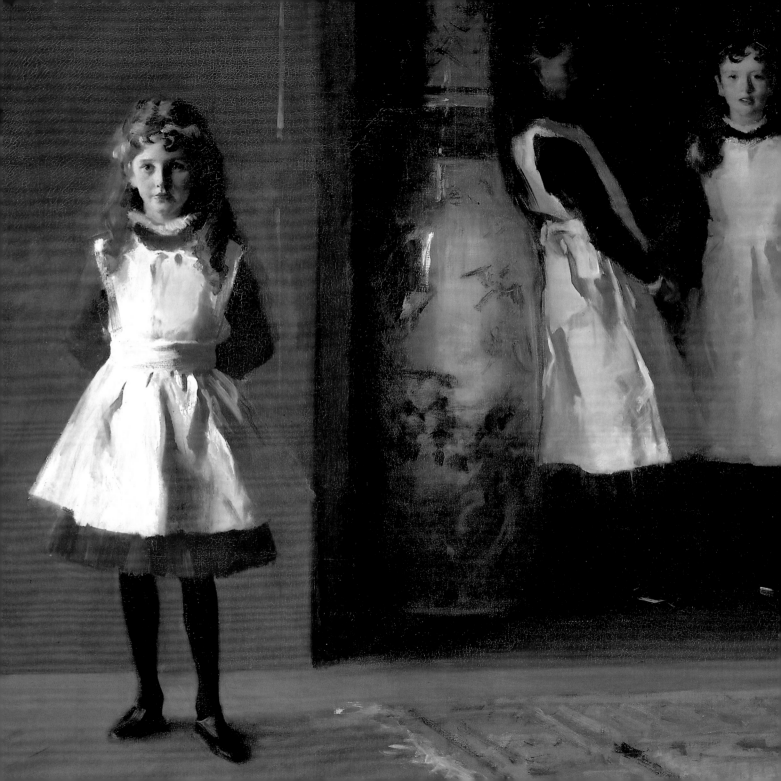

1 France

Academic versus Avant-Garde

The eighteen-year-old Sargent began his formal training in Paris at what now seems a landmark date, 1874, the year of the first exhibition independently organised by the group of artists christened 'Impressionists' in a press review. But for most art lovers that was a minor event in Paris, widely regarded as the world's art capital. Far larger audiences flocked to the vast Salon exhibition, held each year at government expense. The 3,657 works on view at the Salon in 1874 were far more diverse in both subject matter and style than the 165 works in the Impressionist exhibition. None the less, twentieth-century art history has tended to simplify the situation, presenting the Salon as a bastion of conservative art practice, grounded in the traditions of the French Academy and utterly opposed to 'avant-garde' movements such as Impressionism. Even now, Salon art is studied principally as the conservative background against which to highlight Impressionism all the more brilliantly.

For an aspiring artist the situation was more complex: the artists and works on view at the Salon and other Parisian exhibitions offered a bewildering array of choices. It was the 'academic' end of the spectrum, Paris's tradition-al reputation for excellence in art education, that drew Sargent's solicitous parents to the French capital. Their son duly enrolled in the drawing classes at the Ecole des Beaux-Arts, where he learned the basics of academic draughts-manship under Professor Adolphe Yvon. But the Sargents were not wedded to traditionalism, even though they were Americans of gentle birth and sufficient wealth to lead a life of expatriate leisure. For his principal instruction in paint-ing, Sargent did not enrol in one of the Ecole-sponsored teaching studios, or 'ateliers' for painting, such as those of the redoubtable academic painters Jean-Léon Gérôme and Alexandre Cabanel. Instead he entered an independent atelier, one of the most progressive then available, that of

Charles-Emile-Auguste Durand, better known under his professional pseudonym, Carolus-Duran (fig.1). Dispensing with the traditional academic system of careful preliminary drawings and elaborate underpainting, Carolus-Duran taught a more spontaneous *alla prima* method, working directly on the canvas with flowing paint. Carolus claimed to have developed his method through studying the Spanish seventeenth-century artist Diego Velázquez. In one sense, then, the method was traditionalist, rooted in reverence for old master painting. But admiration for Velázquez's art was also a rallying point for the contemporary avant-garde. Carolus was systematising an enthusiasm for Velázquez, shared with avant-garde artists such as his friend Edouard Manet, into a teaching practice that could compete with the more established methods of other Parisian ateliers.

Sargent's choices as a student may seem to map out the middle road that later art historians have made the leitmotif of his entire career – working simultaneously at the Ecole des Beaux-Arts and with Carolus-Duran, he attended evening classes in the more conservative atelier of Léon Bonnat, yet also sketched at the Impressionist exhibitions (fig.2). On the one hand, his art seems tied to the orthodox draughtsmanship, the solid modelling of three-dimensional form, and the reverence for old master painting character-istic of academic methods. On the other, he was as much a master as any Impressionist of the sketchy brushstroke; as we shall see, he was also adept at novel approaches to pictorial composition. His style thus has elements of both of the practices, 'academic' and 'avant-garde', that art histo-rians have tended to characterise as polar opposites. This apparently 'in-between' style causes problems for interpre-tation. For some writers Sargent is a traditionalist who merely adds modernistic fillips to enliven the surfaces of pictures still conceived according to time-honoured princi-

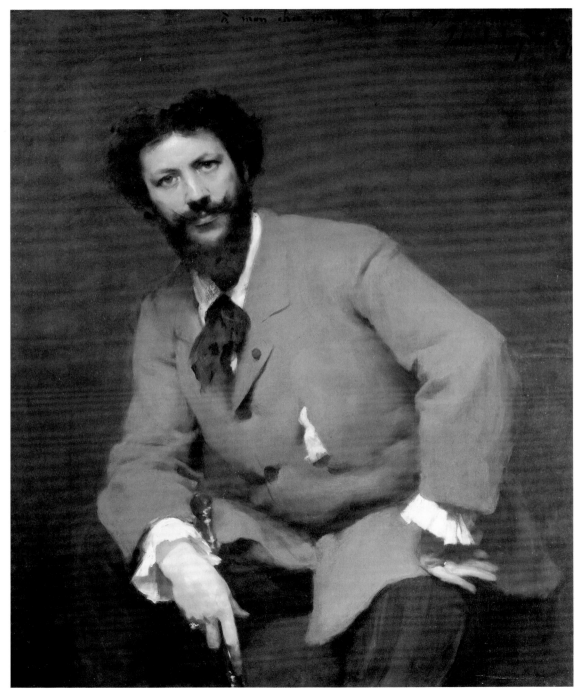

fig.1 *Carolus-Duran* 1879
oil on canvas
116.8 × 95.9 (46 × 37¾)
Sterling and Francine
Clark Art Institute,
Williamstown,
Massachusetts

ples. For others he is a modernist who mitigates the radicalism of his style so that it can appeal to mass audiences, a populariser or vulgariser of avant-garde methods. In either case his work appears to be a compromise between two well-defined art-historical categories. Even in the most favourable accounts, this compromise can appear standoffish or even cowardly: a refusal to take sides in what the twentieth century has considered the most important battle of modern art.

But Sargent resists simple classification as either a modernised academic or a toned-down avant-gardist; his art lacks important defining characteristics of both poles. Sargent never chose the traditional subjects of academic painting: episodes from the past in historical, Biblical or classical costume and mythological nudes, familiar in the work of artists such as Cabanel, Gérôme, Bonnat and William Bouguereau. On the other hand, he never chose the subjects from modern Parisian life that fascinate current students of Impressionist painting; he did not paint prostitutes, barmaids, ballet girls or the French bourgeoisie at leisure. Similarly with style: Sargent never adopted the elaborate procedures of preliminary study, the surface polish or the meticulous finishing of detail characteristic of academic painting. On the other hand, he never espoused the Impressionists' method of design in patches of pure colour.

The traditional art-historical categories, academic and avant-garde, do not supply adequate terms for considering Sargent's work. His painting differs from both modes at least as significantly as it incorporates elements of each. Rather than a conciliatory compromise, Sargent's style might be called challenging. It teases out the contradictions and differences among the options available in the Paris of his artistic education.

Early Successes

We can follow Sargent's movements to and from Paris through pictures that document each of his holidays: a summer on the Brittany coast in 1877, a sojourn on the island of Capri the next year (see fig.9), a trip through Spain to North Africa in 1879–80, extended stays in Venice over

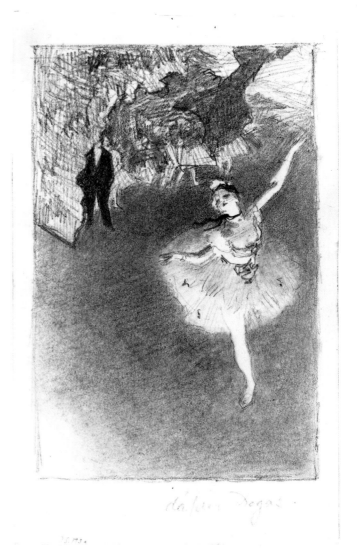

fig.2 Sketch after Degas's *L'Etoile* c.1877
pencil on paper 15.2 × 8.9 (6 × 3½)
*Worcester Art Museum, Worcester,
Massachusetts, Gift of Mrs Francis
Ormond and Miss Emily Sargent*

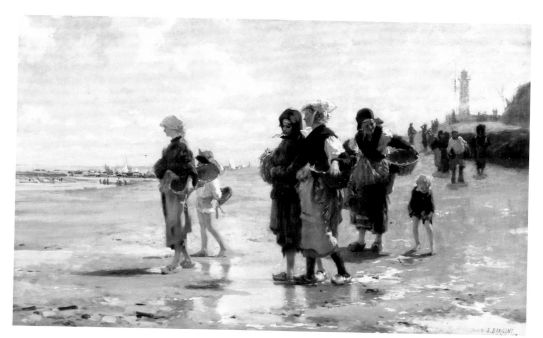

fig.3 *Oyster Gatherers of Cancale* 1878
oil on canvas 96.8 × 123.2
(38⅛ × 48½)
*The Corcoran Gallery of Art,
Washington, DC, Museum Purchase,
Gallery Fund*

the next two years. The resulting pictures could be called escapist fantasies, capturing the local colour of places just distant enough to appear exotic, though still close enough for a Parisian's holidays. But if the pictures sampled traditional, even stereotypical, cultures and ethnicities, from provincial peasant labour to Mediterranean *dolce far niente*, they simultaneously explored the most up-to-date metropolitan styles. *Oyster Gatherers of Cancale* (fig.3) set Breton fisherfolk on a luminous expanse of sand; both the subject matter from peasant life and the bright outdoor lighting recall the work of open-air naturalists then in vogue with Parisian audiences, such as Jules Bastien-Lepage and Léon Lhermitte. *Fumée d'ambre gris* (fig.4) adapts the Orientalist manner of Salon painters such as Gérôme, evoking the brilliant light of North Africa and drawing on stereotypes of oriental sensuality to show an elegant Muslim woman ritualistically perfuming herself with the aphrodisiac ambergris. In scenes such as *Venetian Interior* (fig.5), Sargent was perhaps reflecting on the recent work of his compatriot, James McNeill Whistler, then engaged on a series of etch-

ings of Venetian subjects. Like Whistler, Sargent abandons the celebrated tourist sites favoured by most painters of Venice for back streets and the ramshackle interiors of decaying palaces, but he transforms the delicate touch of Whistler's etching needle into brushy patches of pigment, subtly nuanced in tones of light and dark. The creamy patch of light in the right foreground, applied in a single diagonal stroke, brings alive the half-darkened interior. We try to make out the sketchy figures but we are not quite privy to the activities and preoccupations of these Venetian working women, dispersed in the shadowy gloom.

Each picture parades technical skill. The reflections on the watery Breton beach, the white-on-white of the African courtyard, the multiple light sources of the Venetian interior – all display traditional *tours de force* of the painter's craft, even as they reference the most modern Parisian styles. In each case, too, a distinctive light effect characterises the exoticism of a particular locality, populated by local inhabitants fascinating to metropolitan sensibilities both because they appear characteristic of their environments and

because their lives are not quite fathomable. The sense of detached observation is typical of avant-garde painting in the period. But unlike the Impressionists, Sargent rarely brought this unimpassioned gaze to bear on scenes of contemporary urban life; instead each picture records a transaction between exotic subject matter and Parisian style.

For Sargent's compatriot and staunch supporter, the novelist and critic Henry James, the artist's style was fully perfected, as if by magic, at the very beginning of his career. His painting, James wrote, offered 'the slightly "uncanny" spectacle of a talent which on the very threshold of its career has nothing more to learn'. He characterised this talent as one of vivid perceptiveness: 'In Sargent's case the process by which the object seen resolves itself into the object pictured is extraordinarily immediate. It is as if painting were pure tact of vision, a simple manner of feeling.' Sargent's 'vision' surveyed not only the pictured scene, but the stylistic modes of his contemporary environment; his work glides from open-air naturalism through Orientalism to Whistlerian suggestiveness, yet with no sense of changing gear. In these early subject pictures we see many current Parisian styles but not an eclectic patchwork. Already the young painter could mesh a broad painting style with a compelling drama of light and shade to treat diverse subjects with equal conviction.

Sargent's Venetian pictures, perhaps the most experimental of his early works, were exhibited at small, elite shows, where they attracted mixed reviews; but the principal outlet for his work remained the annual Salon. Whatever reservations young artists may have had about its reputation for conservatism, the Salon promised vastly larger audiences and more press attention than any of the alternatives. Sargent accordingly exhibited there every year between 1877 and 1886. In 1880, just as Sargent's career was beginning to flourish, the government relinquished control of the Salon to a society of artists, but Sargent's rise to fame was uninterrupted. Having won an Honourable Mention in 1879 under the old government-sponsored administration, he achieved a Second Class medal under the new artist-run system in 1881. The press gave him more publicity than usual for a foreign artist, and portrait commissions began

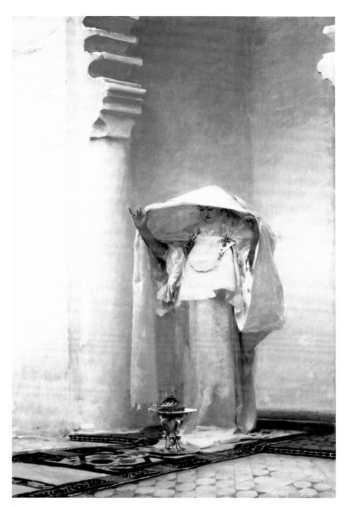

fig.4 *Fumée d'ambre gris* 1880
oil on canvas 139.1 × 90.8 (54¾ × 35¾)
Sterling and Francine Clark Art Institute, Williamstown, Massachusetts

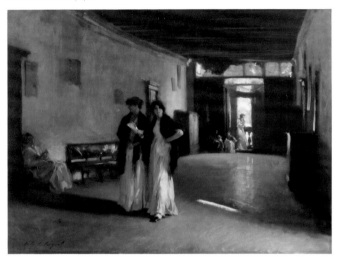

fig.5 *Venetian Interior c.1880–2*
oil on canvas 68.3 × 87 (26⅞ × 34¼)
Carnegie Museum of Art, Pittsburgh.
Museum Purchase, 1920

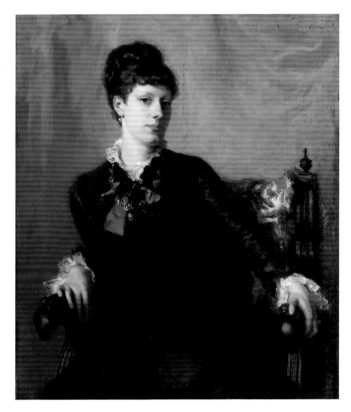

fig.6 *Frances Sherburne*
Ridley Watts 1877
oil on canvas
105.7 × 83.5 (41⅝ × 32⅞)
The Philadelphia Museum
of Art, Gift of Mr and Mrs
Wharton Sinkler

to proliferate. Sargent's early career was one of steadily growing success.

At exhibition, subject pictures such as those described above proved Sargent's versatility. On balance, they marked him as a progressive painter, but one with no doctrinaire allegiance to a particular contemporary school. According to the usual art-historical criteria, these subject pictures ought to constitute the radical side of his work; their broad brushwork and contemporary subject matter are comparable to the Impressionist approaches now accepted as avant-garde. But the subject pictures, despite the range of their explorations, remain within well-established modes for painting in the period. Paradoxically, it was in the more traditional genre of formal portraiture that Sargent made his most daring essays. It was in portraits, too, that Sargent conducted his own analysis of urban modernity, although in ways very different from the Impressionists.

Sargent's first Salon entry, accepted by the jury of 1877 when he had completed less than three years in Carolus's atelier, was a portrait of a family friend, *Frances Sherburne Ridley Watts* (fig.6). It was standard procedure for aspiring portraitists to exhibit portraits of friends, demonstrating their talents in the hope of winning commissions. Two years later, Sargent extended this strategy with the portrait of his teacher (fig.1), counting too on popular interest in the sitter's flamboyant public image. The conspicuous inscription near the top edge calls attention to the tie between teacher and pupil ('to my dear master M. Carolus-Duran, his affectionate student John S. Sargent'). Within two years Sargent had persuasively established his credentials as a por-

traitist of both women and men who were representatives of stylish urban modernity. Moreover, both portraits use striking techniques of posing and lighting, no doubt derived from Carolus's successes in fashionable portraiture (see fig.17), but expertly developed to demonstrate the pupil's inventiveness.

In contrast to older portrait conventions that favoured a static, upright pose to stabilise the sitter's appearance for posterity, Sargent used an asymmetrical, tilting pose for both sitters. This might be associated with avant-garde experiments in portrait pose, as in Edouard Manet's portrait of the poet Stéphane Mallarmé caught in a ruminative moment (fig.7). The tilting pose gives a sense of casual immediacy that contemporary viewers would have associated with the most modern portrait styles, but which was quite at odds with traditional conceptions of portraiture as a genre expressly devoted to extending the sitter's ephemeral existence into the permanence of art. In a portrait photograph taken in the early 1880s (fig.8), Sargent himself assumes the tilting pose, along with a burning cigarette reminiscent of Mallarmé's cigar; he takes the role of the avant-garde artist, disdainful of the conventions of formal portraiture.

But if his poses owe something to avant-garde prototypes, Sargent did not simultaneously adopt the broken brushwork of the Mallarmé portrait, still less the Impressionist technique of dissolving the figure into a play of light and colour. On the contrary, his technique enhanced the solidity of the sitters' bodies by emphasising the tonal range from bright light to dark shadow, the Western artist's traditional means for expressing substantial volume in space. The combination of ephemeral pose with solid bodily substance might be seen as a compromise between new and old approaches to portraiture. However, it also opens novel possibilities for conveying a powerful sense of the sitter's physical presence, no longer in the timeless realm of traditional portraiture but in the vividness of the here-and-now. Even the sitters' hands participate in the effect – each hand is posed as an individual subject, caught in a particular configuration with apparent immediacy, yet modelled in full substance. In the portrait of Frances Watts (fig.6) the slen-

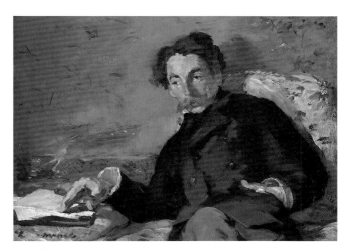

fig.7 Edouard Manet,
Portrait of Stéphane Mallarmé 1876
oil on canvas 27 × 36 (10⅝ × 14⅛)
Musée d'Orsay, Paris

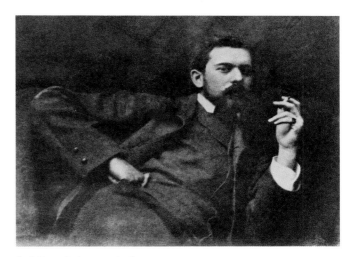

fig.8 Portrait photograph of
John Singer Sargent *c*.1880–3
Private Collection

fig.9 *Head of a Capri Girl* 1878
oil on canvas 43.2 × 30.5 (17 × 12)
Private Collection

der fingers help to convey the sitter's refinement, in that of Carolus (fig.1) the exaggerated bend of the sitter's left hand and the nonchalant grasp of the stick in his right help to suggest his professional deftness as well as his dandified elegance (indeed, the portrait appeared excessively foppish to some American art critics when it was exhibited in New York and Boston in 1880). Hands are notoriously difficult to paint in convincing foreshortening; in these early Salon exhibits Sargent was setting himself technical problems and parading his skill at solving them.

In both portraits the management of light is perhaps the most striking evidence of the young artist's technical aplomb, evidence, too, of his training under Carolus-Duran. As noted above, Sargent did not follow the Impressionists' experiments in replacing the traditional 'academic' organisation by tonal values, that is shades of light and dark, with a system of contrast by colour alone. In its adherence to a strong tonal structure his painting might be said to have remained conservative throughout his life. But Sargent's elaboration of tonality as the basic principle of pictorial design went beyond its role in traditional academic procedure. Indeed, Carolus's teaching method privileged tonal relationships to the neglect of the linear compositional design still taught in more conservative ateliers. Carolus did not even permit his students to draw their designs beforehand, in pencil or charcoal on paper, but encouraged them to begin by brushing the basic tonal relationships, in flowing paint, directly on the canvas surface (see, for example, Sargent's broadly painted *Head of a Capri Girl*, fig.9). As one of Sargent's fellow students, the American Will H. Low, recalled, this meant a more unified approach to design in toned masses, rather than the separation of drawing and colouring into separate phases, as in traditional academic procedure. Another student when Sargent first entered the atelier was R.A.M. Stevenson, cousin of the writer Robert Louis Stevenson (see fig.36) and later a prominent British art critic. Stevenson, too, recalled that Carolus 'separated drawing from modelling with the brush as little as possible. According to him the whole art of expressing form should progress together and should consist in expressing it, as we see it, by light.'

Stevenson wrote about Carolus's method in what may seem at first an odd context, his influential study of Velázquez, first published in 1895. Two decades after his time in the atelier, Stevenson still thought that Carolus's attention to Velázquez's methods was a radical development. By studying the art of the Spanish master, Carolus was seeking an alternative to the traditional art-historical models from the Italian Renaissance – Raphael and the Central Italians for drawing and design, Titian and the Venetians for colour. He used the Spanish painter's position outside the art-historical mainstream to propose a significant alternative to the traditional divide between design and colour. As Stevenson put it, the picture was to be conceived 'rather as an ensemble of tone than as a pattern of lines and tints'. This procedure was utterly different from that of the Impressionists, who were indeed notorious for ridding their palettes of the blacks necessary to the tonal system of Carolus and his students. According to a famous anecdote, telling even if it is apocryphal, Sargent was flummoxed when Claude Monet, a friend in the later 1880s, had no black pigment to lend him. But the tonal system taught by Carolus, and developed by Sargent, was not merely a version of academic painting technique. It opposed the academic separation of line and colour as resolutely as the Impressionists' methods did, but it did this by means of the 'ensemble of tone' rather than by the play of pure colour.

El Jaleo

It was arguably in the work of Carolus's student Sargent, rather than in his own paintings, that the teacher's method was most fully realised. Significantly, it was a Spanish subject that allowed Sargent to take his experiments farthest, and on the grandest scale: *El Jaleo*, exhibited in 1882 (fig.10). At nearly twelve feet across, this would seem to qualify as a *grande machine*, the kind of extravagant production favoured by traditional Salon painters for staking their claims to immortality. It was on a different scale altogether from most avant-garde work, which was designed for the dealer market and the smaller group exhibitions. *El Jaleo* has been harshly treated even in recent writing on Sargent; it is

often accused of excessive theatricality, although the subject is expressly theatrical. Perhaps the implicit comparison is to the Impressionists' scenes of Parisian popular entertainments, where theatricality is often seen to serve the purpose of social comment. By contrast, *El Jaleo* may seem merely frivolous, avoiding the problematic confrontation with modern urban experience to escape into a Spanish fantasy land, the world of Georges Bizet's opera *Carmen* (first performed in Paris in 1875). Although the large scale of Sargent's work demands a bold presentation, *El Jaleo*'s exotic subject matter can appear overdramatised, its tonal contrasts overemphatic to viewers predisposed to prefer smaller, more informal Impressionist pictures.

But it is a narrow view of the history of modern art that elevates Parisian subject matter and Impressionist colour above all other possibilities. *El Jaleo* has often been judged as if it were a less radical version of an Impressionist picture; yet a glance is enough to tell that it is nothing like such a picture. It lacks colour almost entirely, except for accents of magenta and red at the extreme right, and one luscious gleam on the left, an orange left intriguingly on the only empty chair. That detail might indeed be an allusion to Manet's practice, recalling the brilliant yellow lemons in the foregrounds of *Woman with a Parrot* (1866, Metropolitan Museum of Art, New York) or *The Luncheon in the Studio* (1868, Bayerische Staatsgemäldesammlungen, Munich). But if so, the orange, as well as the reds on the right, function principally to point up the difference between Impressionist colour and Sargent's moody ensemble of colourless tones. At the same time, the picture dramatises its difference from conventional academic practice. Indeed, the abrupt juxtaposition of deepest black and brightest white comes close to reversing the academic policy of gradual, controlled modulation from dark to light; one step further and the tonal scheme would fragment into chaos.

Moreover, the picture is flagrantly sketchy, in contrast to the tight handling and polished finish ordinarily used to give important Salon paintings the sense of perfect resolution considered appropriate to their dignified subject matter. Photographs of *El Jaleo* tend to homogenise the loose brushwork that is startling at full scale in the painting itself,

and even more apparent after recent conservation treatment. The combination of academic monumentality with avant-garde sketchiness might, once again, be interpreted as a compromise, but the result was so unfamiliar that some contemporary observers found the picture incomprehensible. The powerful unity of the tonal scheme and the loose handling made it difficult to analyse into an orderly set of lucidly drawn parts, in the way one might approach an academic picture; yet it was too large to experience as the kind of momentary effect one might find in an Impressionist picture. Was it, then, an unnaturally enlarged 'impression' or an unfinished, and therefore incoherent, *grande machine*? In an article of 1888 on Sargent, R.A.M. Stevenson referred to the work not as a painting at all, but as a 'large sketch'. Henry James thought that the picture had 'the quality of an enormous "note" or memorandum, rather than of a representation'. And when the picture reappeared at an exhibition at the Fine Art Society in London later in 1882, a critic for the *Magazine of Art* found it positively disturbing:

> The spectator is dazzled by a general glare of light, and bewildered by a whirl of tumbled drapery, so that he has no time to consider what may be the function of those uncouth blacknesses behind. Only after some moments of anxious examination does it dawn upon him that these strange excrescences purport to be human beings playing the guitar.

In conclusion, the critic stressed the sacrifice of tidy academic draughtsmanship to the unsettling drama of light and shade: 'Throughout the work drawing is immolated to value.'

These comments, ostensibly about technique, also suggest the critic's distaste for the subject matter – a glare and a whirl describe the eroticism of the dancer, while out of the tonal gloom emerge dehumanised creatures, and the very shadows are 'uncouth'. James, too, found the setting disreputable, noting the 'placards, guitars, and dirty fingermarks' on the rear wall; the picture's 'defect' he found 'difficult to express save by saying that it makes the spectator vaguely uneasy and even unhappy'. If Sargent was not confronting contemporary Parisian life, he was exploring a notoriously degraded European underclass, the gypsies; and he did it, too, on a scale normally reserved for the deeds of heroes and saints. Contemporary writing on the gypsies, such as the story by Prosper Mérimée on which Bizet's opera was based, stressed their anarchic refusal to integrate with the European societies around them. Mérimée's gypsies are atheists, thieves, bandits and liars, living a makeshift existence in southern Spain. In such writings wild and abandoned dancing became a symbol of gypsy separatism and irrationality. The title of Sargent's picture may refer to a particular gypsy dance, the 'Jaleo de Jerez', described as licentious and frenzied in contemporary books on dancing. More generally, the word *jaleo* implies 'uproar' or even 'brawl'. Some recent commentators have pointed to the elegance of the principal dancer, and the improbably luxurious sheen of her white skirt, as signs that Sargent has sanitised this scene of gypsy anarchy. But for many contemporaries the elevation of such a subject to the scale and seriousness of a Salon *grande machine* was an act of effrontery only exacerbated by the startling contrast between dazzling white and 'uncouth blacknesses'.

The glare of the footlights not only catches the flourish of the white skirt, blurred at the edges to suggest motion, but isolates this moment in the dance. The simultaneous effect of immediacy and monumentality carries to an extreme what Sargent had already begun to explore in his early portraits. The light casts eerie shadows from below, dehumanising the facial features into schematic masks. Above the heads the shadows play moodily on the wall, an almost empty space covering nearly half the huge surface of the canvas; on one level the blank expanse emphasises primitive squalor, on another it elaborates the crude setting into an 'ensemble of tone'. The shadows of the men's hats, near the back wall, are sharply defined, but that of the dancer is more moody and strange; her distance from the wall transmutes and magnifies her shadow into a ghostlike form. Her asymmetrical position, precariously tilted on a high-heeled shoe, helps to suggest her rightward progress across the shallow stage. Sargent had perhaps learned from Degas techniques of suggesting motion through the place-

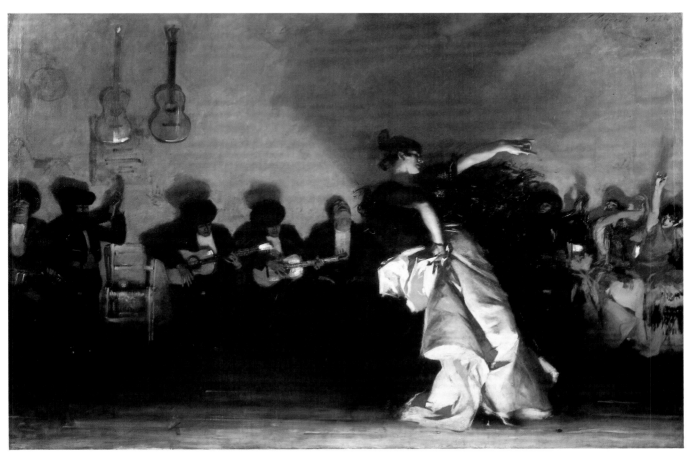

fig.10 *El Jaleo* 1882
oil on canvas 237 × 352 (93⅜ × 138½)
Isabella Stewart Gardner Museum,
Boston, Massachusetts

fig.11 *The Spanish Dance* 1879–80
oil on canvas 89.5 × 84.5 (35¼ × 33¼)
The Hispanic Society of America, New York

traditions of gypsy dancing as a unique moment of transcendence, achievable only on rare occasions but always to be desired; the parallel with sexual ecstasy is obvious. The dancer appears in profile, her face in shadow, and she is heavily draped. She lacks the conventional signs of erotic availability familiar in nineteenth-century paintings of exotic women. But perhaps it is not so much the dancer's individual sexual allure, as the erotic intensity of the collective experience that registers, that could indeed make some sophisticated viewers 'anxious', 'bewildered' or even 'unhappy'.

Many Parisian critics responded more positively to *El Jaleo*. As noted in the catalogue to the recent exhibition focusing on the picture at the National Gallery of Art in Washington, its Salon appearance coincided with a campaign to revive Bizet's *Carmen*, accused of indecency when it first appeared but subsequently championed by some critics as an important new development in French music. Sargent had seen gypsy dancing on his trip to Spain in 1879, recording his impressions in works such as *The Spanish Dance* (fig.11). However, he designed *El Jaleo* later in his Paris studio, perhaps recognising that a gypsy dancing subject, so reminiscent of certain scenes in *Carmen*, was likely to attract attention as both audacious and topical. However, the Salon picture contains no clues to a story of sexual violence like that of the opera. Its drama is pictorial rather than narrative, conveyed through the figures' positions in space and light rather than through psychological characterisation or narrative interaction. Perhaps James was right to distinguish it from 'representation'. Its theatricality is not so much the record of an event as the enactment of a performance which the viewer must conjure from the sketchy brushwork and deep shadows.

The Subjects of Portraits

In his early years in Paris Sargent took care not to pigeonhole himself as a specialist in portraiture. Not only did he exhibit important subject pictures, such as *El Jaleo*, he presented his portraits as independent works of art rather than mere likenesses. This was perfectly consistent with the high

ment of figures in empty space; a few years earlier he had sketched one of Degas's compositions (fig.2), in which the ballet dancer's off-centre placement parallels that of the gypsy dancer in *El Jaleo*.

But Sargent's vast composition strikes a different balance between the ephemeral scene and the permanence of the work of art; at this scale, the arrested moment cannot be explained away as an 'impression'. The strident light effects function partly as a visual analogue for the raucous sounds suggested by the title, a collective hysteria of hand-clapping, finger-snapping, guitars and raised voices. But the exaggeration of the light effect to the point of maximum contrast suggests that we are witnessing, not a random moment in the performance, but its climax. The self-absorbed figures appear to have lost consciousness of their individual roles and entered that psychological state mythologised in the

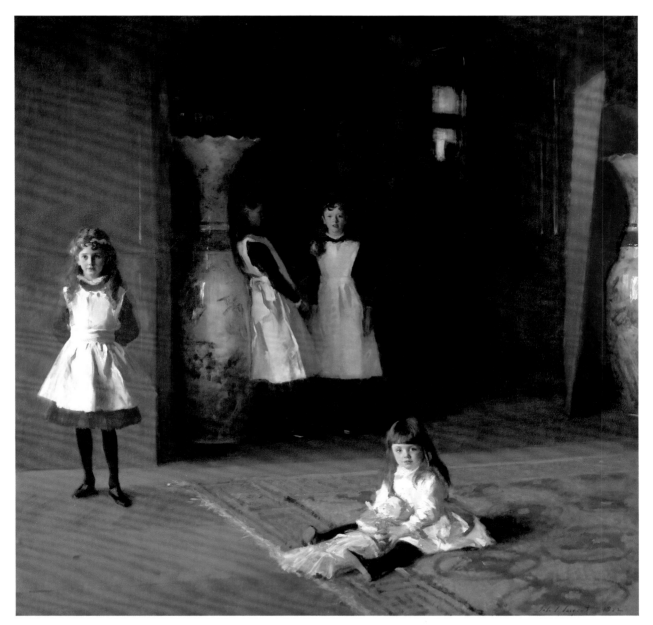

fig.12 *The Daughters of Edward Darley Boit* 1882
oil on canvas 221.9 × 222.6 (87⅜ × 87⅝)
The Museum of Fine Arts, Boston. Gift of Mary
Louisa Boit, Julia Overing Boit, Jane Hubbard Boit
and Florence D. Boit in Memory of their Father,
Edward Darley Boit

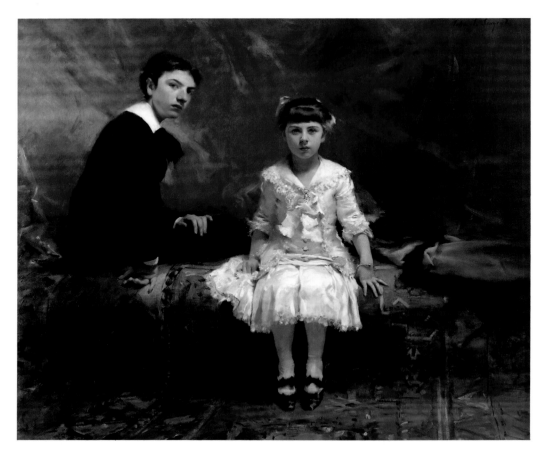

fig.13 *Portrait of Edouard and Marie-Louise Pailleron* 1881
oil on canvas 152.4 × 175.3 (60 × 69)
Des Moines Art Center Permanent Collection

status of portraiture in traditional art theory. As the academic theorist Charles Blanc stressed in his influential work, *Grammaire des arts du dessin* (*Grammar of the Arts of Design*, 1867), portraiture was responsible simultaneously to the demands of faithful likeness and fine art. Portrait photography, increasingly available since the 1850s, raised the stakes for the painter – mere likeness would no longer suffice, now that it could be had more cheaply, and without the tedium of long sittings, from the photographer. Now, more than ever, the portrait painter must offer something more than likeness. As Blanc put it: 'The painter endowed with spirit can evoke the spirit of his sitter; but how can a machine evoke a human soul?'

Indeed, it might be argued that Sargent's most important subject pictures, after *El Jaleo*, were portraits. *The Daughters of Edward Darley Boit* (fig.12), shown at the Salon of 1883, actually violates the basic requirement for recognisable likeness, since the face of one of the daughters is almost totally obscured. Moreover, two of the four are removed to a background as shadowy as that of *El Jaleo*, and the four sitters collectively occupy a startlingly small proportion of the total surface area. The composition sacrifices individual likeness to the evocation of a childhood world; it is a subject picture as much as a group portrait. The vast scale of the whole picture, of the strangely empty room and of the blue-and-white vases emphasises the childish smallness of

the figures. The canvas is square, an unusual format for either a portrait or a subject picture. The critic for the *Revue des deux mondes* stressed its oddness, saying that it was 'composed after new rules: the rules of the game of four corners'. Perhaps the comment also refers to the curious disposition of the figures, dispersed as if they are playing a childhood game whose rules are unfathomable to adults. One aspect of this mysterious ritual is growing up. The sisters in their white pinafores appear at successive stages of child development, zigzagging back through the picture space from the infant in the foreground through the middle child on the left to the near-adolescent pair behind. Do the encroaching shadows of the background allude to their impending loss of innocence?

The shadowy interior, the plays on scale and even the shape of the canvas recall the crucial prototype for this picture, Velázquez's celebrated group portrait of the Spanish royal family, *Las Meninas* (*c*.1656, Museo del Prado, Madrid), slightly taller than its width but close to a square. The conspicuous reference to the prototype provides a context, above all, for the unsentimental characterisations of the children. The Spanish precedent motivates a significant departure from the preciousness that surrendered the sitters, in much nineteenth-century child portraiture, to adult delectation. The American children of Edward Darley Boit, as well as the French *Edouard and Marie-Louise Pailleron* (fig.13), retain an enigmatic quality, not quite accessible to adult rationality or available for adult pleasure. Something similar might be observed of Sargent's portraits of women. One of the usual functions of fashionable female portraits was to characterise the women's attractions, as in Carolus-Duran's portrait of 1875, *Mlle de Lancey* (fig.17), where the engaging glance encourages the viewer to enjoy the sitter's beauty and finery. By contrast, Sargent's portraits of female sitters, such as *Frances Watts* (fig.6) or the mother of the Pailleron children, *Madame Edouard Pailleron* (fig.14), suppress all signs of coquettishness. Their reserved glances do not seek to entice.

Sargent's portraits represent his engagement with modern urban life. Unlike the Impressionists and such English painters of the urban scene as William Powell Frith,

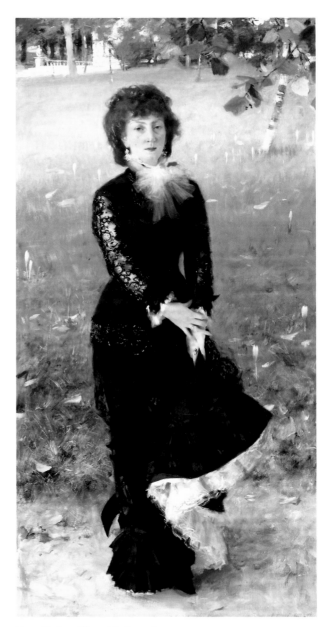

fig.14 *Madame Edouard Pailleron* 1879
oil on canvas 208.3 × 100.4 (82 × 39½)
The Corcoran Gallery of Art, Washington, DC; Gallery Fund and Gifts of Katherine McCook Knox, John A. Nevius and Mr and Mrs Landsell K. Christies

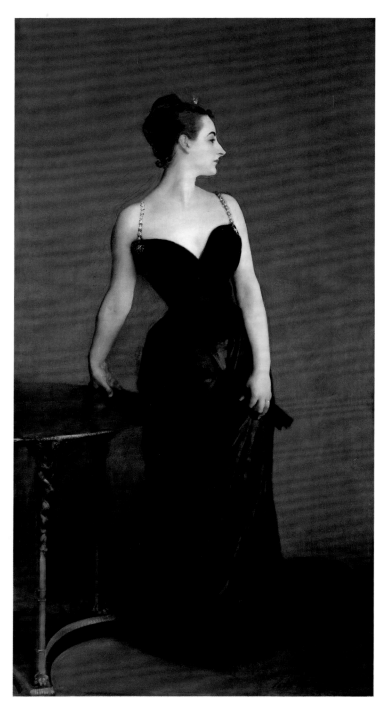

fig.15 *Madame X 1883–4*
oil on canvas 208.6 × 109.9 (82⅛ × 43¼)
The Metropolitan Museum of Art. Arthur
Hoppock Hearn Fund, 1916

he neglected the mixing of classes often seen as crucial to modern urban experience, concentrating on the sequestered world of the upper class alone. The Boit and Pailleron children are sheltered in their elegant Paris apartments. If Frances Watts and Madame Pailleron appear thoroughly modern women, independent-minded and self-possessed, that too may be a privilege of their class. But the depiction of upper-class life was not an easy option. As Sargent and his audience were to discover, the upper class was no more a realm of unproblematic social stability than the lower strata often given more prominence in our views of nineteenth-century history.

Madame X

One decisive status symbol for the avant-garde artist, at least in the popular imagination, is a scandal, staking out the crucial gap between the artist's radical aims and the comprehension of the public and critics. The reception of *El Jaleo* cannot qualify as a genuine scandal; despite some critical hostility, it was generally seen as working within the bounds of acceptable modes for Salon painting. But the case may be different with the portrait of Virginie Gautreau, exhibited at the Salon of 1884 (fig.15); even favourable critics insisted that the picture shocked the general public. As the critic of the powerful art periodical, the *Gazette des beaux-arts*, reported, crowds gathered before the picture exclaiming 'Détestable! Ennuyeux! Curieux! Monstrueux!' Moreover, the controversy turned around issues similar to those involved in the most celebrated avant-garde scandal of the nineteenth century, that of Manet's *Olympia* in 1865: female sexuality and the transgression of class boundaries. In the case of *Olympia* the disputed boundary was at the low end of the social scale. If Madame Gautreau's portrait questioned the limits of the upper class, the ramifications were no simpler.

More than one French critic imported an English phrase to describe Sargent's sitter – 'professional beauty', designating a woman who deploys her personal qualifications and skills, after the middle-class model of professional self-advancement, to usurp an elite status ordinarily attainable

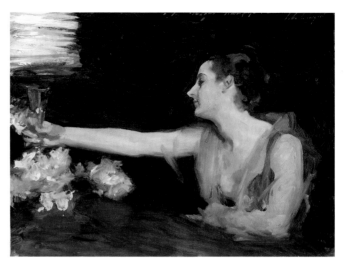

fig.16 *Madame Gautreau Drinking a Toast c.1883* oil on panel 32 × 41 (12⅝ × 16⅛) *Isabella Stewart Gardner Museum, Boston*

fig.17 Carolus-Duran, *Mlle de Lancey 1875* oil on canvas 157.5 × 200 (62 × 78¾) *Musée du Petit Palais de la Ville de Paris*

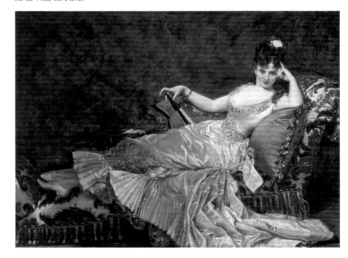

only by right of birth. Although the Salon catalogue listed the picture merely as *Portrait de Mme ****, a common formula for preserving a sitter's anonymity, many critics were able to identify the sitter as Virginie Gautreau, an American expatriate who had married a wealthy French banker and attained considerable notoriety in high society both for her beauty and for her rumoured infidelities. But the portrait is more than a passive likeness of the real Gautreau, more even than a penetrating analysis of her equivocal social position. It creates the quintessential visual image of a social type already described and classified under the stock category 'professional beauty'. The shock was to recognise not Virginie Gautreau but the social type embodied and perfected in the portrait image.

This was scarcely a novel function for portraiture, ordinarily expected to convey the sitter's class position as well as individual appearance. But traditional portrait conventions aimed to present the signs of class identity as 'natural' characteristics of the individual sitter. The portrait of Gautreau, instead, flaunts the artificial contrivances with which the sitter stakes her claim to elite status. The portrait uses an orthodox pose, with the sitter dressed in formal evening attire and represented at full length. One arm leans on the most standard of portrait properties, a highly polished table. But on closer inspection the pose is carefully choreographed rather than effortlessly assumed. The right arm does not rest easily on the table but swivels to form an elegant serpentine contour against the background. The neck twists to display a striking profile but the strain is apparent in the tendons. As several critics noted, even the dress is painted to seem donned for effect, leaving a gap between the bodice and the body underneath; as the critic for the *Revue des deux mondes* put it, the bodice 'seems to flee contact with the flesh'. But most startling is the uniform whiteness of the make-up, overtly artificial mimicry of aristocratic pallor. The conspicuous red ear has been described as an outlandish feature of the real Gautreau's make-up, and indeed it also appears in the informal oil sketch Sargent made of Gautreau while he was planning the large portrait (fig.16). But the ear also functions as a startling visual reminder of the colour of flesh and blood,

otherwise eliminated from the figure's artful self-presentation. Moreover, some critics observed that her hair was artificially coloured with henna. For nineteenth-century audiences cosmetics were a contentious issue. Charles Baudelaire's *In Praise of Cosmetics*, published in 1863, set out to shock, lauding the artistry of cosmetics for correcting the faults of nature. In the portrait the make-up signals exactly that: it demonstrates the professional's skill at overriding the 'natural' social distinctions, innate and thus presumably inherent in flesh and blood, by artificially managing the colour, shape and demeanour of the body itself.

Sargent's painting, then, pays elaborate tribute to the sitter's professionalism. As the art historian Albert Boime has argued, the image marks a collaboration between the two American expatriates, both winning their way to high status through their professions. Indeed, both do it through the artifice of 'painting', but for the woman the only available support for the 'paint' is her own body. The phrase 'professional beauty' implies a double infringement of the upper-class boundary, first through the 'professional' skill associated with middle-class endeavour, second through 'beauty', substituting sexual power for gentle birth. Gautreau's sexuality, as Sargent interprets it, is overtly upper class, disdaining the earthy sensuality of the common prostitute and indeed any suggestion of warmth or comfort. The skin is icily unblemished, and the breasts are shaped rather by the stiff black contour of the bodice than the swelling of flesh. The cinched-in waist was a standard attribute of the upper-class woman, distinguished from the fleshier types associated with the lower classes. The profile is sharp and severe, and conforms to the specifications for aristocratic bone structure in contemporary writings on physiognomy: it is manifestly orthognathous, forming a straight perpendicular line from forehead to lower jaw. These physical features describe a sexuality that is cold and remote, under the professional control of the sitter rather than available for the male viewer's pleasure. This contrasts abruptly with other contemporary portraits of young women, such as *Mlle de Lancey* by Sargent's own teacher (fig.17). Carolus's sitter has the cinched-in waist and expensive finery of the upper-class woman, but her refinement is

inviting and alluring. Both poses place their sitters on complete display, revealing the *décolletage*, but Gautreau appears self-consciously to pose herself, while de Lancey seems to be posed. Carolus's sitter appears relaxed and at leisure, but Gautreau is at work; in her case the invitation to look does not amount to an encouragement to touch. Sargent modifies his notoriously 'sketchy' handling to trace sharp contours quite unlike the malleable curves of *Mlle de Lancey*, and refuses to allow the viewer even to make eye contact with the sitter.

Perhaps Gautreau ought to have been pleased by Sargent's tribute to her professional artistry; indeed, the portrait might be read as a refutation of her rumoured sexual availability. But in another sense she was right to be outraged. By using her individual appearance as the vehicle for his compelling presentation of the social type, 'professional beauty', Sargent was transgressing another boundary, that between the portrait and the subject picture. Gautreau had not commissioned the portrait. It had been Sargent's idea, from the first, to transform her distinctive appearance into a dramatic display of his own craft. Nonetheless, critics were well within their rights to review the picture as a portrait, imputing the characteristics of the 'professional beauty' to the individual sitter. That caused embarrassment to Gautreau and her family, who asked Sargent to withdraw the painting from the Salon exhibition. Although he refused, he was left with a large, unsold and unsaleable canvas.

Nonetheless, Sargent had himself photographed with the portrait prominently on display in his Paris studio (fig.18), and indeed he had some reason to be proud of the controversy the picture excited. The flamboyant aesthete and supporter of the avant-garde, Comte Robert de Montesquiou, later remembered *Madame Gautreau* as the pinnacle of Sargent's achievement. This lends a certain glamour to the precocious genius, reaching his peak at only twenty-eight and then burning out after the fashion of youthful heroes of the avant-garde, such as Rimbaud, who renounced poetry at the age of nineteen. But if the portrait raised Sargent's avant-garde profile, it damaged his chances of future commissions.

In a sense, then, Sargent was taking an even greater personal risk than Manet with *Olympia*, when he subjected the upper reaches of the class system to scrutiny. In the longer run, though, both scandals benefited their painters' reputations. *Olympia* entered the French national collection in 1889, with the aid of a subscription fund to which Sargent contributed. Perhaps he mused on the parallel when, in 1916, he finally sold *Madame Gautreau* to his own country's most important museum, the Metropolitan Museum of Art in New York. In both cases the artist's most notorious scandal metamorphosed into a national artistic treasure once his fame had become unassailable. Sargent then retitled the portrait *Madame X*. The new title respected the sitter's wish to dissociate herself from the image, but its detective-story flavour also called attention to the picture's controversial history, and by extension the artist's avant-garde youth.

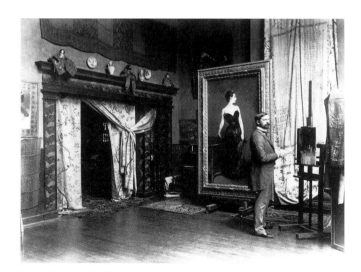

fig.18 Photograph of Sargent in his Paris studio with the portrait of Madame Gautreau, *c*.1884
Private Collection

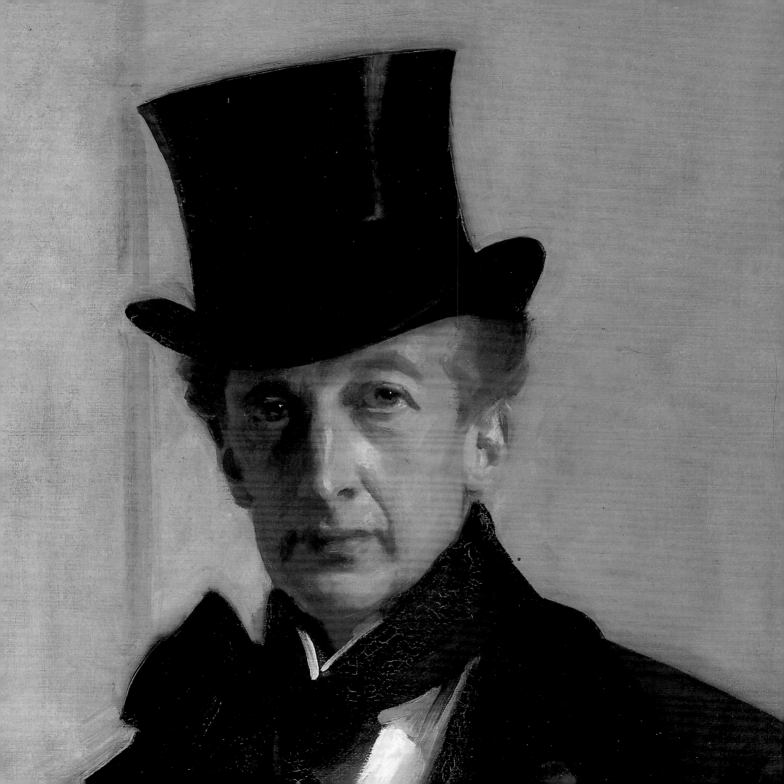

2 Britain

The Move to London

It is often said that the scandal over the Gautreau portrait prompted Sargent's move to London, and there may be some truth to that view. However, Sargent had been keeping an eye on the British portrait market for at least two years previously. His first exhibit at the Royal Academy, London's equivalent to the annual Salon exhibition, was a portrait of the French gynaecologist Dr Pozzi, shown in 1882 (fig.19). We might expect this spectacular display of technique to have created an *éclat*, with its sumptuous red-on-red colour scheme reminiscent of old master portraits of cardinals and popes. But British critics were then favouring more restrained and sombre approaches to male portraiture. In contrast to portraits such as Frank Holl's statesmanlike *Joseph Chamberlain* of 1886 (fig.20), the characterisation of Dr Pozzi must have appeared to verge on irresponsibility – he seems less like a reputable professional man than a self-dramatising actor or impresario. One embroidered slipper peeps from beneath the dandified dressing-gown; the intricate, dazzlingly white frills of collar and cuffs set off a handsome head, dreamy rather than businesslike, and a pair of hands exaggerated in the refinement of their elongated fingers. The possible allusion to Pozzi's professional skill, as the inventor of the technique of bi-manual examination of the ovaries, would have been lost on most British observers, and in any case is subsumed in the evocation of the doctor's mannered stylishness.

In 1882 Sargent knew little of the British art world, although he must have seen British portraits at the Universal Exposition held in Paris in 1878. However, increased familiarity with British taste did not cause him to tone down his portrait style. If Sargent meant to win fame or fortune in London, it was not by emulating the sober respectability of such portraitists as Holl. After extended visits in 1884 and 1885, he took up residence in London in the spring of 1886. He chose a studio not in one of the more respectable artists' quarters such as Fitzroy Square or Holland Park, but in London's closest approximation to an artistic Bohemia, Tite Street in Chelsea, famous in avant-garde circles as the site of Whistler's 'White House' and around the corner from Dante Gabriel Rossetti's studio until his death in 1882. Whistler had been forced to sell the White House after his lawsuit with the critic John Ruskin bankrupted him in 1879. That event added to the avant-garde mystique of both Whistler and Chelsea, which he continued to frequent. Indeed, Sargent moved into a studio that Whistler had recently been using. Perhaps the younger artist sensed Chelsea's potential as a meeting-place for the fashionable and the artistic, or perhaps his own studio helped that reputation to develop. Sitters travelling from the more solidly upper-class enclaves of Mayfair or Belgravia could enjoy the frisson of visiting artistic Bohemia in Tite Street (fig.21).

Many writers on Sargent have seen his move to London moralistically, as a mercenary change of course from the acute social analysis of the Gautreau portrait to flattering the complacency of the British aristocracy. Certainly, there were financial incentives for a move to London. Indeed, Sargent arrived at precisely the moment when British art critics were beginning to note a massive shift in the marketplace away from the narrative pictures so popular in the mid-Victorian period and toward grand-manner portraiture. In his autobiography of 1894 Henry Stacy Marks, a painter of humorous subject pictures in historical costume, published a 'dirge' lamenting 'the days which we sold pictures in'; by 1914 his colleague G.D. Leslie thought portraiture the artist's only reliable means of earning a livelihood in Britain. Even the artists who had made their reputations as social realists in the 1870s such as Luke Fildes, Frank Holl

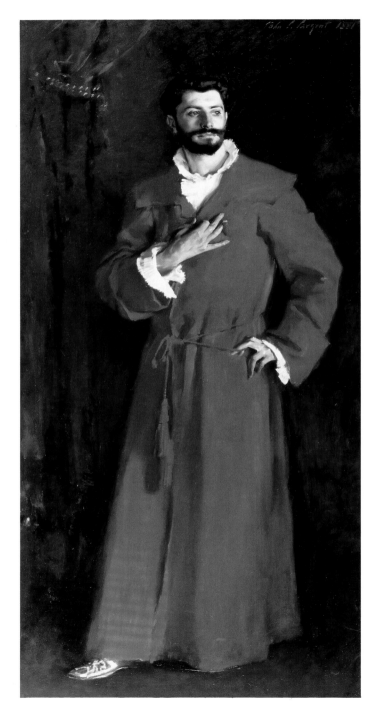

fig.19 *Dr Pozzi at Home* 1881
oil on canvas 202.9 × 102.2 (79⅜ × 40¼)
*The Armand Hammer Collection, UCLA,
at the Armand Hammer Museum of Art
and Cultural Center, Los Angeles,
California*

fig.20 Frank Holl, *Portrait
of Joseph Chamberlain* 1886
115.6 × 86.4 (45½ × 34)
National Portrait Gallery

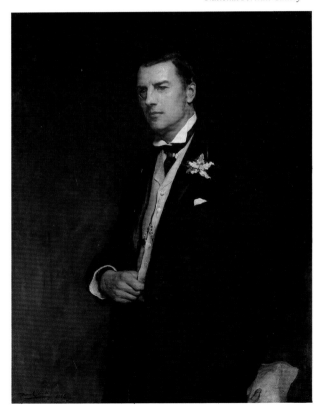

(see fig.20), and Hubert von Herkomer, turned increasingly to portraiture in the next decade.

But if Sargent was cashing in on the British vogue for portraiture, he was prepared to take risks. His portrait style continued to appear audaciously extrovert at the London exhibitions. His success in Britain would depend on building a clientele prepared to forgo a sober image of themselves, after the manner of a Holl or Herkomer, in favour of one that was distinctly modern, flamboyantly 'arty' and not necessarily predictable. That might well appeal to the notorious gambling instincts of the British upper classes, as mythologised in contemporary writings on aristocratic moral decline, but the project was scarcely without risk.

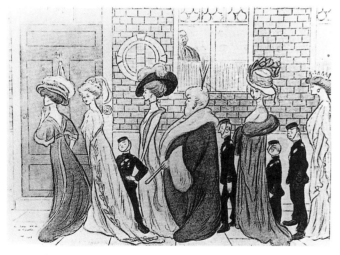

fig.21 Max Beerbohm, *Tite Street: The Queue Outside Mr Sargent's* Whereabouts unknown

Sargent's British Sitters

That Sargent did make a success of his British portrait career has passed from history into legend. By 1910 the artist and critic Walter Sickert was satirising the critics who fell 'flat-belly' before Sargent's fame, in an article wittily entitled 'Sargentolatry'. The consolidation of Sargent's reputation in the intervening period can be traced not only in increasingly adulatory critical responses, but through the steady rise in the social status of his sitters, in a country where distinctions of rank were perhaps the most jealously protected in Europe. The trend is evident in the series of Sargent's group portraits of three sisters; this was a traditional category, famous through eighteenth-century examples such as Sir Joshua Reynolds's *Montgomery Sisters* (Tate Gallery) and already revived in nineteenth-century group portraits. Sargent's initial essay in the category was among his first English commissions, preceding his move to London: *The Misses Vickers* (fig.22), shown first at the Salon in 1885, then at the Royal Academy the following year. The women were the daughters of Colonel Thomas Edward Vickers, the proprietor of a Sheffield engineering firm, and therefore unequivocally middle class, despite their father's extreme wealth. Perhaps the portrait emphasises their background: the gloomy interior uses Velázquez-inspired shadows to evoke the stereotypical grimness of the industrial north of England, while the simple coiffures and fresh complexions are as distant as possible from the stylised Parisian chic of the recent portrait of Gautreau. Some critics in both Paris and London thought the likenesses unflattering, despite their unaffected, slightly girlish charm; perhaps the critics were responding to the subtle signs of their provincial breeding.

For the next few years most of Sargent's exhibited portraits featured sitters outside the charmed circle of the aristocratic elite. As we shall see, many were American. It was perhaps *Lady Agnew of Lochnaw* of 1893 (fig.23) that began to enhance the social prestige of the Sargent portrait (Lady Agnew was the granddaughter of an English baron and the wife of a Scottish baronet). When Sargent returned to the three-sisters category in 1900, it was to paint the gen-

fig.22 *The Misses Vickers* 1884
oil on canvas 137.8 × 182.9 (54¼ × 72)
Sheffield Galleries and Museums Trust

uinely patrician daughters of the Hon. Percy Wyndham (fig.24). This is a much more flamboyant portrait than that of the Vickers, with a more overt reference to eighteenth-century prototypes, befitting a family whose own ancestors might have commissioned such a work. Indeed, the grand-manner portrait on the rear wall provides the women with a visible lineage (it reproduces a portrait of their mother by G.F. Watts). The glinting gold frame and elevated position of the portrait-within-the-portrait help also to characterise a palatial interior far more splendid than the Vickers's dark drawing room. In contrast to the horizontal format and sombre colouring of the earlier picture, the Wyndham portrait soars vertically. The highlights on dresses and jewels read simultaneously as daringly modern patches of brilliant paint and symbols of opulence. But in 1900 Sargent may still have been the portraitist of choice only for the more artistically minded among the aristocracy. The Wyndhams prided

themselves on their artistic tastes, and were central members of the intellectual clique of patricians known as the 'Souls'. The dazzling highlights of the Sargent portrait may have served to distinguish the women, not only from social inferiors who might prefer middle-class sobriety for their portrait images, but from the staider reaches of the upper class not privy to the effervescent wit on which the Souls prided themselves as a class-within-a-class. For Roger Fry, just beginning his career as a critic and himself of sufficiently elevated social origins to understand the Souls' special pretensions, the portrait surpassed all contemporary efforts 'to seize the exact *cachet* of fashionable life'.

From this time, though, titled sitters became more prominent in the lists of Sargent's Royal Academy exhibits. Sargent's group of three sisters, shown in 1902, reaches even higher in the social scale (fig.25). The Acheson sisters were daughters of the Fourth Earl of Gosford and granddaugh-

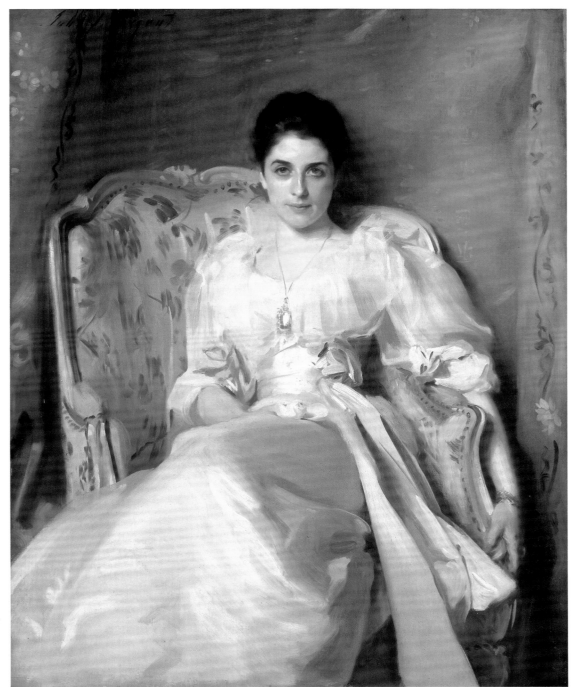

fig.23 *Lady Agnew of Lochnaw* 1892
oil on canvas
127 × 101 (50 × 39¾)
National Gallery of Scotland

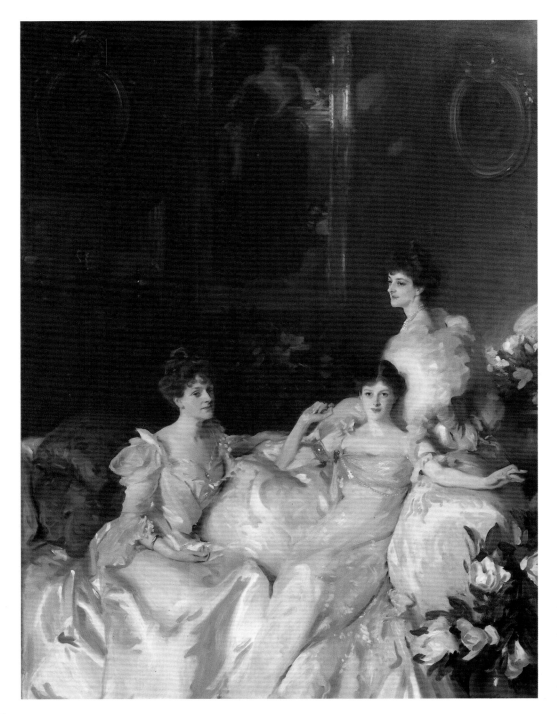

fig.24 *The Wyndham Sisters
(Lady Elcho, Mrs Adeane
and Mrs Tennant) 1899*
oil on canvas
292.1 × 213.7 (115 × 84⅛)
*The Metropolitan Museum of Art,
New York. Wolfe Fund, Catherine
Lorillard Wolfe Collection, 1927*

ters of the Duchess of Devonshire; it may have been the Duchess who commissioned the portrait for Chatsworth, where it still hangs. Of Sargent's triple portraits, this makes the most overt reference to the eighteenth-century prototype, with its artful posing of the three women around the urn. Even the costumes have an eighteenth-century flavour. Sargent seems to have exchanged his early allegiance to Velázquez for the brighter tonality and feathery brushwork of the old masters of British portraiture such as Thomas Gainsborough or Sir Thomas Lawrence. Yet the portrait offers a creative reinterpretation of such prototypes. The women appear to collaborate with the painter in a scene of play-acting, striking poses as self-consciously artificial as that of *Madame X*. If the touch seems more light-hearted than in the Gautreau portrait, that is appropriate. These women are not 'professionals' but born and bred to a life of what had just been christened 'conspicuous leisure' in an influential book by Sargent's compatriot, the economist Thorstein Veblen (*The Theory of the Leisure Class*, 1899). According to Veblen, the upper class signalled its economic power over the working masses not simply by indolence but by the pursuit of activities 'conspicuous' for their failure to result in any product. Dressed in their finery, the Achesons can scarcely be accused of productive labour as they pick oranges from an ornamental urn in the park of an extensive country estate. The futile activity serves simultaneously as the pretext for a group portrait, itself a quintessential leisure-class prerogative, and as a demonstration of the women's performance of their leisure-class duties.

In addition to the Acheson portrait, the Royal Academy exhibition of 1902 included portraits of the Duchess of Portland and of Lord Ribblesdale (fig.27), another member of the Souls: this was Sargent's most spectacular collection of aristocrats at a single exhibition. From this date, his reputation as the painter *par excellence* of the British aristocracy was unassailable, for better or worse.

On the other hand, still in 1902, Sargent contributed yet another portrait of three sisters: *The Misses Hunter*, daughters of a Durham mine owner (fig.26). Evidently the artist's services remained egalitarian, at least according to the capitalist principle of availability to the highest bidder

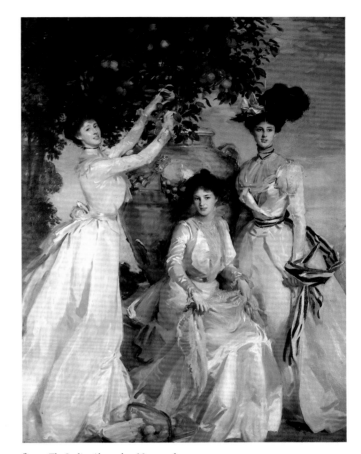

fig.25 *The Ladies Alexandra, Mary, and Theo Acheson (The Acheson Sisters)* 1902 oil on canvas 375.2 × 198.1 (106 × 78) *Devonshire Collection, Chatsworth*

(the Hunters' father could vie with his social superiors in sheer wealth). But the comparison between the Achesons and the Hunters raises questions. Do the more sober dresses and less glittering execution of the Hunters' portrait mark their social difference from the Achesons? Or does the mere existence of a triple portrait by Sargent admit the Hunter family into the upper ranks of a modernised class system, no longer limited by outmoded distinctions of birth but now ordered more simply, in the pure plutocratic terms of the new century?

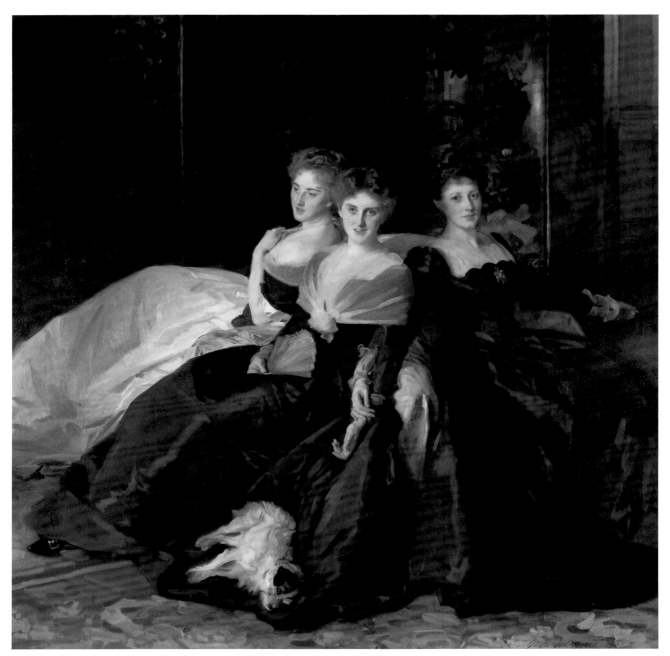

fig.26 *The Misses Hunter* 1902
oil on canvas 229.2 × 229.9 (90¼ × 90½)
Tate Gallery

Society and the Status Quo

Sargent's portraits of upper-class sitters are routinely described as affirming the social status quo. But was there a status quo in late-Victorian and Edwardian Britain? When Sargent moved to London, the hereditary aristocracy of Great Britain was beginning a fall from grace perhaps unequalled in the history of class rivalry. As the social historian David Cannadine has argued, their triple decline in wealth, status and political power between 1880 and World War I was exceptional both for its speed and its decisiveness. Salient symbols of the aristocracy's decline were the sales of hereditary treasures, including family portraits by British old masters. Paradoxically, noble families were repairing their ailing fortunes by selling original eighteenth-century portraits at the same time as they bolstered their public image with new grand-manner portraits in a style deliberately reminiscent of the old.

But there were new social groups eager to purchase portraits of aristocratic ancestors not their own. International financiers such as the Rothschilds and newly wealthy Americans built great collections of eighteenth-century British portraits dispersed from dwindling country estates. These new social groups acquired not only the possessions but the social roles of the old elite. Some historians have characterised the change as the coalescence of a new and coherent upper class based exclusively on wealth, and uniting old money with new. On this view, a portrait by Sargent would be the prerogative of the new plutocratic class simply by virtue of its high cost. Late in the 1890s Sargent raised his fee for a full-length portrait to 1000 guineas, equivalent to at least £50,000 in the money of the 1990s; a single portrait by Sargent cost a multiple of the annual salary of a reasonably well-off member of the middle class. The portraits, then, are indices of the hyperbolic scale of plutocratic wealth at the turn of the century.

But the situation was more complex, as the marks of upper-class ascendancy devolved onto a more diverse range of social groups. Bankers and industrialists might constitute a new aristocracy of wealth, but did not necessarily wield political power, increasingly the province of professional politicians. Yet another group formed the social elite, which might include decayed aristocrats, 'professional beauties' and celebrities from the worlds of art, letters and entertainment. Instead of a unified aristocracy of wealth, many historians have described a pluralistic assortment of social groups seeking niches in a constantly shifting hierarchy. A clique such as the Souls might represent one such niche, using private games and esoteric jargon to create a sheltered enclave within a high-society world expanding and diversifying with disconcerting rapidity. Sargent painted members not only of the Souls but other elite sub-groups, including some who could not afford his prices. The Gautreau portrait was the first of a number of occasions when Sargent painted a portrait, without commission, of a sitter whose appearance struck him. Later examples included prominent figures from the arts, such as the Spanish dancer *La Carmencita* (1890, Musée d'Orsay, Paris) or the English actress *Ellen Terry* (1889, Tate Gallery). In other cases the commission could come from an institution or a group of subscribers, so that the portrait reflected the sitter's professional distinction rather than personal wealth. One way or another, Sargent's range encompassed virtually all of the sub-classes of the new international elite of the turn of the century. It is worth asking which was cause and which effect: upper-class social status or the portrait by Sargent?

Sargent was not, then, simply painting the 'status quo'. Indeed, his portrayal of an upper class in the very process of reformulation is more 'modern' than many kinds of class representation conventionally considered avant-garde. The peasants and prostitutes in much French Impressionist painting represent classes characterised as traditional or timeless. By contrast, Sargent's portraits rendered visible a flux in the upper reaches of the class system that was unequivocally novel, indeed disturbingly so to many.

But trickier questions remain. Did Sargent's portraits serve as agents of cohesion for the new upper class of the turn of the twentieth century, blending the diversity of individual origins into a single, compelling evocation of elite glamour? Did the portraits crystallise a class image immediately recognisable as superior through references to traditional grand-manner portraiture, yet also ultra-modern

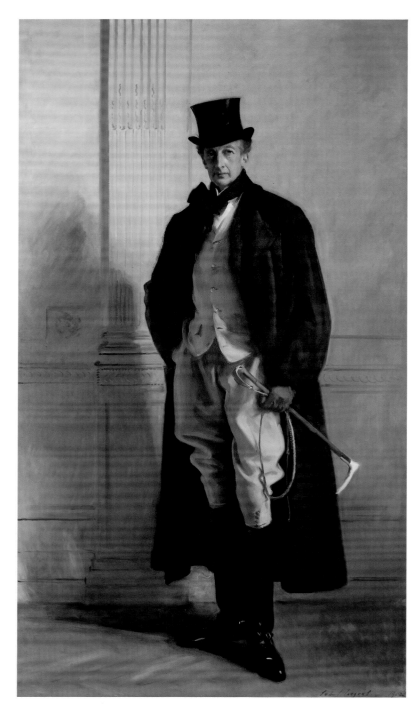

fig.27 *Lord Ribblesdale* 1902
oil on canvas 258.5 × 143.5 (101¾ × 56½)
The National Gallery, London

through the use of advanced compositional techniques and impressionistic brushwork? Or did Sargent's portraits present visible marks of social difference, exquisitely subtle, yet legible by a sensitised eye? Did they discriminate social origins as the character Henry Higgins could, in George Bernard Shaw's play *Pygmalion* (1913), by the most minute distinctions in their speech? Perhaps the answer is unrecoverable, since a century later we have lost the key to a supremely intricate code; but we should beware of reading the social clues in Sargent's portraits too simplistically.

An intriguing example is the portrait of Lord Ribblesdale (fig.27), apparently the very quintessence of the English male aristocrat. And indeed the sitter had every credential for the role: like the Wyndham sisters, Ribblesdale was a Soul and impeccably well born. However, the portrait was not a commission; as with the Gautreau portrait, the artist picked out an individual whose physical appearance inspired him to crystallise a social type. Sargent marshalled dress and accessories to enhance the idea he had in mind. At first he tried posing Ribblesdale against a grandiose portico, but eventually he eliminated virtually all distraction, placing the aristocrat simply against a pale background. The equally understated riding clothes recall eighteenth-century portraits of patrician men in hunting or military dress, but the stereotype had been given a new twist in Veblen's *Theory of the Leisure Class*. In Veblen's theory hunting serves both as a relic of the aristocracy's violent seizure of power in the distant past and as a symbol of their conspicuous leisure in the present. The polished black boots and riding crop, held in the position of a sword, appear as vestiges of military prowess, now transferred to the realm of conspicuous leisure. Should we read the portrait of Lord Ribblesdale, then, as the embodiment of hereditary power or as typical of a class whose role in national affairs was dwindling to leave them undisputed masters only of elitist sports?

Sargent's picture refers to traditional formulae for the portraiture of powerful men, such as Reynolds's famous *Commodore Augustus Keppel* (fig.28). Ribblesdale turns his toes at right angles in accordance with what eighteenth-century etiquette prescribed as a graceful pose. But Sargent

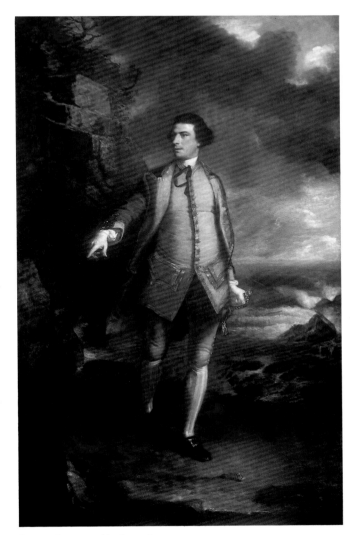

fig.28 Joshua Reynolds, *Commodore Augustus Keppel* c.1752–3
oil on canvas 238.8 × 147 (94 × 57⅞)
National Maritime Museum, London

modifies the tradition, eliminating the demonstrative hand gesture and pulling the outline into a compact mass, as if to suggest self-containment rather than the extension of command. Even more striking is the elongated and emaciated physical type. Indeed, Lord Ribblesdale is anatomically bizarre by comparison with traditional canons for figural proportions. From the top of his gleaming hat to the elegant point of his polished boot, he measures over ten heads. He is, then, fully one-third taller than the seven-and-a-half heads that Charles Blanc's *Grammaire des arts du dessin* recommended as the ideal standard derived from classical sculpture. Reynolds's male portraits had conformed to the time-honoured standard. Commodore Keppel is significantly shorter than Ribblesdale – and stouter. While Keppel's waistcoat bulges, Lord Ribblesdale's accentuates his slenderness, hanging just loose enough to be consistent with fine English tailoring. The organisation of the colour in vertical strips of white and black helps to make elongation the formal principle of the entire canvas. So, too, do the slender proportions of the background pilaster, another traditional motif in grand-manner portraiture.

On permanent display at the National Gallery in London, the portrait continues to mesmerise viewers as the quintessence of the English lord. But can we assume that this strange physique makes a declaration of male aristocratic power or an affirmation of the status quo? Perhaps the combination of overbearing height and emaciation indicates over-refinement. As the art historian Mary Cowling has noted, some contemporaries described the aristocratic physique as deteriorating through a social exclusiveness that had prevented intermarriage with more robust social groups. Excessive tallness and leanness could be interpreted as signs of Norman ancestry, unequivocally aristocratic but unhealthy without an admixture of Saxon vigour. *Lord Ribblesdale* might, then, be read as an image of aristocratic decline. Instead of confirming the timeless authority of the aristocrat, the portrait perhaps captures his appearance at a particular moment in the modern history of his class. More broadly, Sargent's portraits of diverse participants in the shifting social mix of the period can be seen not as documents of an eternal social hierarchy but as glimpses of an unexampled flexibility and fluidity in the class system. In that case they represent a novel departure for the very genre of portraiture, shifting the emphasis from securing social stability to dramatising social flux.

Sargent's Jewish Sitters

One category among Sargent's portrait sitters represented a group whose status was in the most dramatic transition: Jews, whose rapid rise to fortune and professional achievement in the nineteenth century was successful enough to arouse violent envy. Perhaps Sargent's portrait of the art dealer Asher Wertheimer (fig.29) alludes to the sitter's recent social advancement. He seems to start toward the viewer, in dramatic contrast to Ribblesdale's stock-still stance. Wertheimer's expansive gesture with the cigar, the suggestion of well-fed rotundity under the expensive suit of clothes, and the penetrating glance create a character that was instantly recognisable to contemporaries as Jewish, prosperous and businesslike. Although some critical comments were overtly anti-Semitic, it is more difficult to judge the painting itself, as the art historian Kathleen Adler has argued in a searching study of Sargent's portraits of Jewish sitters. On the one hand, the portrait confirms certain stereotypes about the Jewish businessman; the signs of Wertheimer's wealth mark him as a parvenu. But the portrait is also a celebration of Wertheimer's success. Had Sargent suppressed recognisable signs of his Jewishness, the portrait would be anti-Semitic indeed. The subtlety with which Sargent's painting alludes to physiognomic characteristics popularly associated with Jewishness treads this balance with utmost care. In comparison, for instance, with John Everett Millais's portrait of Disraeli (fig.30), Wertheimer's 'Semitic' features are understated. The full-face presentation hides the outline of the nose, more prominent in Disraeli's three-quarter profile. The full lips, often seen as a 'Semitic' feature and again evident in the Disraeli portrait, are upstaged by the moustache; the glance manages to be engaging as well as shrewd.

Wertheimer himself had no reservations about Sargent's sympathy, for he went on to commission a series of por-

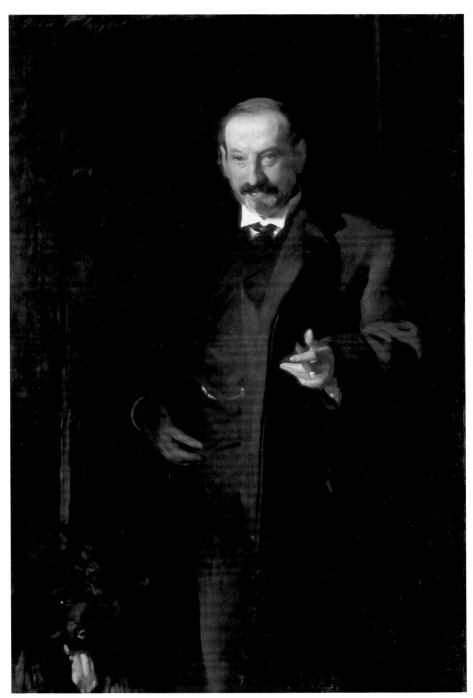

fig.29 *Asher Wertheimer* 1898
oil on canvas
147.3 × 97.8 (58 × 38½)
Tate Gallery

traits of other members of his family, eventually amounting to twelve important paintings (see fig.60). Moreover, nine of them were bequeathed to the nation after his death. The presence of the portraits in the British national collection, alongside the celebrated portraits of Reynolds and Gainsborough, might seem to constitute literal proof that portrayal by Sargent could confer social distinction. The Wertheimer portraits were displayed as a group when a new 'Sargent Room' opened at the Tate Gallery in 1926, apparently confirming Wertheimer's good judgement in choosing Sargent to 'transmit his fame to posterity', as the critic Roger Fry put it. But there is a significant undertone of disdain in Fry's account of the Wertheimer portraits, a curious mixture of anti-Semitism, more general snobbishness about new wealth, and disparagement of Sargent's art. After 1926 Sargent's reputation went into steady decline; perhaps that is why the Wertheimer portraits have rarely been displayed since then, and never as a group. But the fortunes of the artist and those of his sitters may be more intimately linked. If Sargent's spell has ceased to work on many twentieth-century art critics, that may be because it has been difficult to share the social dream his portraits conjure, the myth of sparkling glamour that can encompass Wertheimers as well as Souls.

However, the magic was always precarious. In the portrait of *Mrs Carl Meyer and her Children* (fig.31) the mother seems about to slide off her fashionable Louis Quinze sofa, her tiny feet scarcely adequate to anchor her on the gilded footstool, while her children are not protected in the traditional maternal embrace but lurk behind the sofa as if unsure of their right to enter the scene. The picture might be read as dramatising the uncertain social position of Jews in high society. Critics, as usual, made conspicuous reference to the sitters' Jewishness. Henry James described the children's 'shy olive faces, Jewish to a quaint orientalism, faces quite to peep out of the lattice or the curtains of a closed seraglio or palanquin'. Some contemporaries observed a touch of caricature in Sargent's faces, intensified by the very deftness of his rapid brushwork; here the olive skin tones, dark eyes and slanting eyebrows might be elements of racial caricature. But, as we have seen, the most

fig.30 John Everett Millais, *Benjamin Disraeli, Earl of Beaconsfield* 1881 oil on canvas 127.6 × 93.1 (50¼ × 36⅝) *National Portrait Gallery, London*

impeccably born British aristocrats might also be caricatured, by tallness and angularity. Moreover, the allusions to eighteenth-century elegance in the poses, setting and costumes of the Meyer family are comparable to those in the portraits of the Wyndhams and Achesons. The question remains unsolved, perhaps insoluble. Should we interpret the marks of social difference so evident to contemporaries as regrettably divisive or laudably pluralistic?

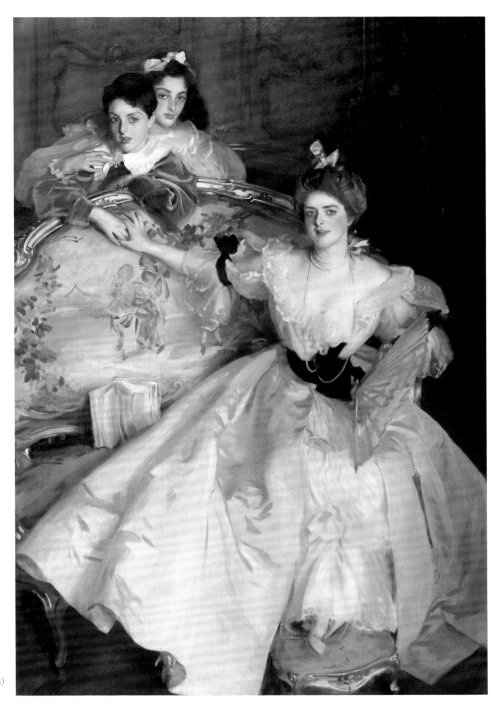

fig.31 *Mrs Carl Meyer
and her Children* 1896
oil on canvas
201.4 × 134 (79¼ × 53¾)
Private Collection

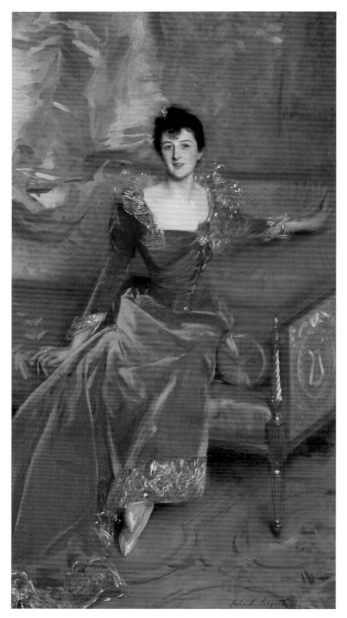

fig.32 *Mrs Hugh Hammersley* 1893
oil on canvas 205.7 × 114.9 (81 × 45¼)
The Metropolitan Museum of Art,
Promised Gift of Mr and Mrs
Douglass Campbell, in memory of
Mrs Richard E. Danielson

Nervous Energy

It was not only Sargent's Jewish sitters who could appear precariously poised within their glittering surroundings. Many of Sargent's non-Jewish portrait subjects seem less to be sitting than falling off their chairs, such as *Mrs Hugh Hammersley* (fig.32) or *Mrs Charles Thursby* (fig.33). Mrs Thursby's footstool is as ineffectual as Mrs Meyer's. These attitudes represent an extreme development of the tilting pose Sargent had used in his earliest portraits. Since then his brushwork had become much bolder, which intensified the effect of immediacy. The pattern of diagonals representing the highlighted folds of Mrs Hammersley's skirt increases the sense of movement through the figure, complementing her asymmetrical pose. Each diagonal is one supremely confident stroke of the brush, surprisingly large in scale and indeed difficult to read unless the viewer stands back from the picture. Similarly, the nervous swirls and whorls of the carpet under Mrs Thursby's feet dissolve into chaos at close range; from farther away, they resolve as if by magic into a thoroughly convincing representation of an antique carpet highly fashionable in the period. The carpets in both portraits are signs of utmost opulence, but not of security. The brushwork is too loose and open in texture to provide a stable platform for the women. Moreover, the carpets are seen from a high viewpoint so that they appear to tilt upwards on the picture surface. We may even wonder why the delicately gilded furniture does not slide forward out of the picture space. Grand-manner portraiture traditionally adopted a viewpoint well below the sitter, to make the viewer look deferentially up at the figure. Sargent radically alters not only this practice but the whole sense of stability and permanence conferred on the sitter by older portrait conventions.

The Victorian critic George Moore wrote perceptively, although with a touch of condescension, about the portrait of Mrs Hammersley:

It is essentially a picture of the hour; it fixes the idea of the moment and reminds one somewhat of a *première* at the Vaudeville with Sarah [Bernhardt] in a new part. Every one is on the *qui vive*. The *salle* is alive with

murmurs of approbation. It is the joy of the passing hour, the delirium of the sensual present. The appeal is the same as that of food and drink and air and love.

We might expect Moore, an ardent supporter of French Impressionism, to applaud the evocation of the passing moment. Instead he applies a criterion more appropriate to the traditional aims of portraiture, remarking that the picture fails to transcend the 'sensual present' and become a lasting work of art. Moore presents Sargent's style as merely fashionable, popular only for a moment before a new fashion takes its place. Indeed, fashionableness is a crucial element in Sargent's characterisations of upper-class women. According to Veblen, fashionable dress was a crucial attribute of the leisured class, a form of what he christened 'conspicuous consumption', since dresses would be discarded for a new fashion long before they had worn out their usefulness. The sense of instability in the portraits might then function, paradoxically, as a status symbol. If the ephemeral dress fashions, along with the precariously tilted chairs and carpets, may soon be outmoded, that proves the women's – or more likely their husbands' – economic power, ready to purchase new accoutrements as fast as fashion dictates. The women's body types, too, display features that Veblen associated with the leisure-class woman – the cinched-in waists and tiny feet declare the women's exemption from useful labour. Despite the compelling sense of individual likeness in the portraits of Mrs Meyer, Mrs Hammersley and Mrs Thursby, they look startlingly similar in pose, bending abruptly at a minuscule waistline. Their angularity and weightlessness are class markers, the antithesis of characterisations of peasants and working-class women as plump, robust and earthbound.

Sargent did not invent the body type, already familiar in cartoons and caricatures of upper-class women such as those by the *Punch* illustrator George Du Maurier. But his portraits were perhaps decisive in enhancing the prestige of the type, widely imitated by other artists. Indeed, Sargent virtually founded a school of society portraiture. Although art critics from the 1890s onwards tended to lament the ubiquity of Sargentesque styles among the works of

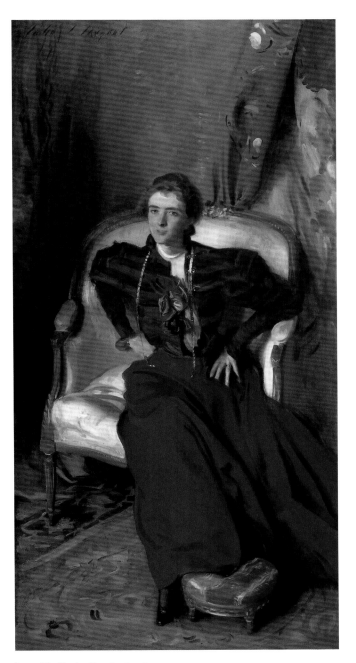

fig.33 *Mrs Charles Thursby* 1897–8
oil on canvas 198.1 × 101 (78 × 39¾)
The Newark Museum, New Jersey

younger portraitists at the London exhibitions, 'Sargentolatry' produced many fine portraits, and sometimes interesting new developments, in the work of artists such as Giovanni Boldini, Ambrose McEvoy, James Jebusa Shannon and others. However, another contemporary portraitist, the Hon. John Collier, regretted the exclusiveness of the fashionable body type in his book of 1910, *The Art of Portrait Painting*:

> I am aware that there is the most uncanny power of adaptation in the female form to the prevailing fashion, but it is not unlimited. For instance, it is now the fashion for women to be tall, and it is remarkable how many of them contrive to be in the fashion; but there are exceptions.

It is easy to sympathise with Collier's sarcasm but we cannot pride ourselves on greater diversity in our own age; the fashion photography of the late twentieth century still promotes a stereotype of inordinate tallness and thinness for women.

The emaciated body types and seemingly instantaneous poses of many of Sargent's figures contributed to a sense that the figures were unnaturally alert or nervous. As early as 1885, Sargent's lifelong friend, the writer Vernon Lee (fig.34), worried that this was becoming a mannerism. In a letter to her mother she wrote: 'I fear John is getting rather into the way of painting people too *tense*. They look as if they were in a state of *crispation de nerfs*.' This sense of nervous tension, noted also by contemporary critics, might be related to the insecurity of an upper class in flux or to the vulnerability of wealth in an era of unpredictable shifts in fortune. As noted above, even the most expensive of carpets, as painted by Sargent, does not necessarily provide a stable platform to stand on. In female portraits, though, the sense of nervous intensity has further ramifications, given the widespread contemporary perception that the incidence of nervous disease or hysteria was growing among women of the higher classes. The issue of female hysteria could be deployed on either side of debates about women's rights. For those who opposed women's involvement in public life nervous disease was one more proof of women's

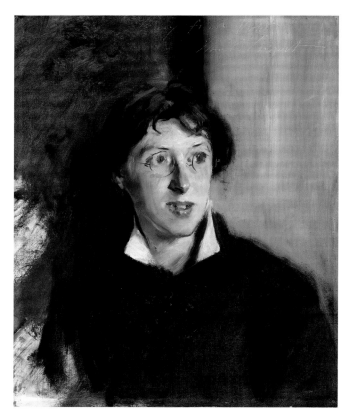

fig.34 *Vernon Lee* 1881
oil on canvas 53.7 × 43.2 (21⅛ × 17)
Tate Gallery

biological incapacity to engage in strenuous physical or mental endeavour, to be added to menstruation and childbearing as signs of innate feminine weakness. Others argued that stress and frustration were inevitable results of a life of enforced leisure: the only outlet for the energies of middle- and upper-class women trapped in the ideology of leisure-class idleness might be nervous disease or hysteria. The extreme alertness of Sargent's female figures, leaning forward as if ready to spring into action, could also be read in different ways. For some commentators the women's vivacity was compelling and appealing; for others the women looked jittery or unsettled.

If there are signs of nervous disease in some of Sargent's

female portraits, they are not incompatible with an evocation of elegance. A similar mixture of refinement and morbidity characterises certain portraits of male figures from the arts, sometimes hinting at a romanticised link between creativity and physical debility. These portraits belong to a category widely practised in the 1890s, for instance in Walter Sickert's portrait of the consumptive Aubrey Beardsley (1894, Tate Gallery) or Whistler's portrait of the French aesthete Robert de Montesquiou (1891–4, Frick Collection, New York). In such portraits the male aesthete shares the elongation and emaciation associated with the aristocratic physique, redeployed to connote extreme refinement. Perhaps the physical type also characterises the aesthete as a dying breed, like the aristocrat. Baudelaire had made some such equation, writing of the extreme refinement of the male 'dandy' in his famous essay of 1863, 'The Painter of Modern Life'.

Sargent's portrait of the artist *W. Graham Robertson* (fig.35) elaborates his dandified elegance with suggestions of morbidity in the pallid complexion and extreme emaciation of his form. Although Robertson was nearly thirty when the portrait was painted in 1894, he appears a mere boy. As Robertson told the story in his engaging book of reminiscences, *Time Was*, Sargent had approached him as he did Gautreau and Ribblesdale. The idea for the portrait depended not only on Robertson's waif-like appearance but on the elongated lines of his overcoat, to be juxtaposed with his fluffy dog in a haunting contrast between artistic asceticism and sensuousness. When Robertson objected to wearing the coat during sittings on hot summer days, Sargent protested that the garment was indispensable. Robertson recalled that he was obliged to remove the rest of his clothes to pose in the overcoat alone: 'I became thinner and thinner, much to the satisfaction of the artist, who used to pull and drag the unfortunate coat more and more closely round me until it might have been draping a lamp-post.' The result of Robertson's misery was another of Sargent's icons, epitomising the 'decadent' glamour of the *fin-de-siècle* aesthete, just as the portrait of Madame Gautreau had conjured the professional beauty and that of Lord Ribblesdale the turn-of-the-century aristocrat.

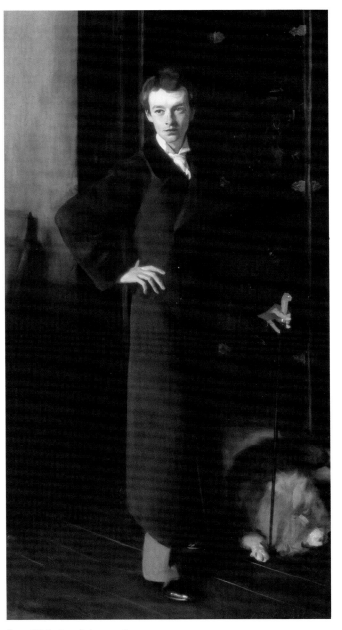

fig.35 *W. Graham Robertson* 1894
oil on canvas
230.5 × 118.7 (90¾ × 46¾)
Tate Gallery

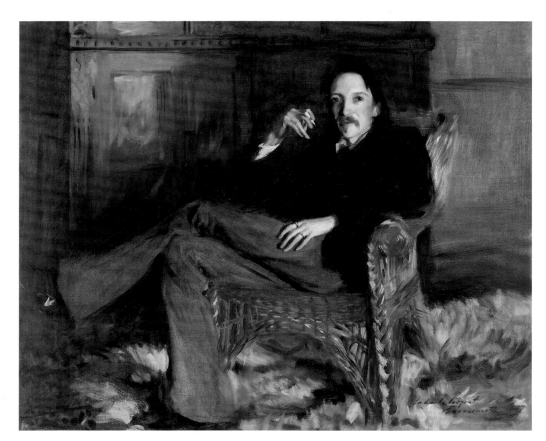

fig.36 *Robert Louis Stevenson* 1887
oil on canvas 50.8 × 61.6 (20 × 24¼)
*Bequest of Charles Phelps and Anna
Sinton Taft, The Taft Museum,
Cincinnati, Ohio*

Aestheticism and Impressionism

We have been searching Sargent's portraits for minute signs of social distinction. But a different method of interpretation was often adopted during Sargent's lifetime, one that played down social meanings in favour of qualities seen as purely aesthetic. Sargent's fellow student R.A.M. Stevenson had become active as an art critic since his return from Paris. His extravagant eulogies of Sargent's work in the late 1880s when he was critic for the influential weekly magazine the *Saturday Review* played an important role in building Sargent's success in Britain. By then Sargent had already painted Stevenson's more famous cousin *Robert Louis Stevenson* (fig.36), giving him all the characteristics of the

male creative genius. We might read the thin fingers and pensive glance as signs, simultaneously, of the writer's refinement and his illness (he was to die in 1894); his cousin would have been more likely to respond to the economy and sensitivity of brushwork that traces a febrile hand, a plait of straw or a tuft of carpet with equal deftness.

In 1888 the critic contributed a whole article on the painter to the important periodical, the *Art Journal*. Here he carefully distinguished Sargent's work from that of painters such as William Powell Frith, concerned with telling stories and pointing morals. Sargent's aims, according to Stevenson, were more purely aesthetic: 'Mr. Sargent's painting is strict painting, as Bach's fugues are strict music … He relies on nothing which may suggest to the mind a poetry which

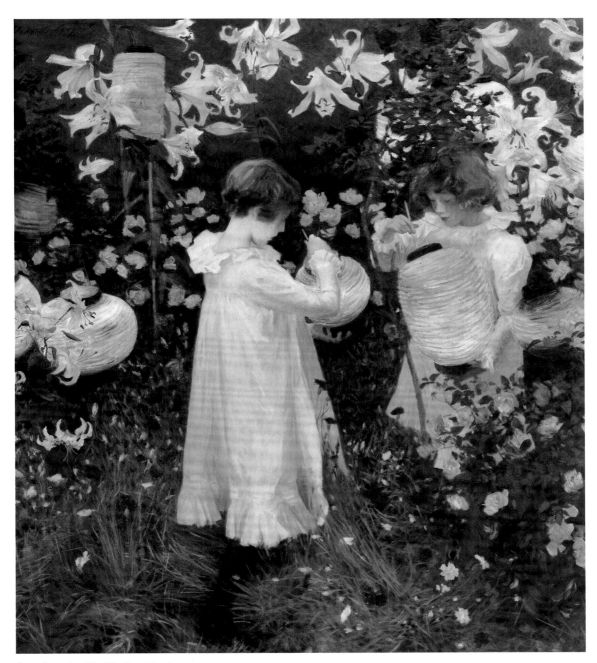

fig.37 *Carnation, Lily, Lily, Rose* 1885–6
oil on canvas 174 × 153.7 (68½ × 60½)
Tate Gallery

is not visible. The beauty of light playing on the varied surfaces of things, that is his matter.' Stevenson praises Sargent in the 'pure art' terms associated with the British Aesthetic Movement. The disparagement of Frith, the comparison to music and the notion of a purely visual poetry are all standard motifs in contemporary writing on artists such as Whistler, Rossetti, Albert Moore, Frederic Leighton and Edward Burne-Jones. At the time of Sargent's move to London those artists represented the British equivalent of the 'avant-garde'. In revolt against the moral and narrative concerns of earlier Victorian painting, they placed new emphasis on what Stevenson called 'style in Art'.

As noted above, Sargent's Tite Street studio placed him in the neighbourhood associated with Whistler and Rossetti, and therefore with Aestheticism. But the London art world was diversifying. A group of young artists, many of whom had trained in France or had sympathies with the newer developments in French art, formed the New English Art Club, which held its first exhibition in 1886. Sargent contributed two pictures, while showing the same year at both the Royal Academy and the Grosvenor Gallery, the stronghold of Aestheticism. At this time both Aestheticism and the more French-orientated styles of younger painters, increasingly called 'Impressionist' in the press, had claims to represent the advanced section of British art. Whistler could be linked to either Aestheticism or Impressionism; and so, too, could Sargent.

In Sargent's first important London success, *Carnation, Lily, Lily, Rose*, exhibited at the Royal Academy in 1887 (fig.37), the double light effect might be seen as a deliberate conflation of Impressionism and Aestheticism. The cool twilight, painted out of doors in orthodox Impressionist fashion, sets off the warmer glow of the Chinese paper lanterns, evoking a world of artifice and exoticism reminiscent of Aesthetic painting and poetry. As Stevenson remarked, 'nothing [is] more suited to the spirit of the age than a fantastic subject treated on a basis of realism'. Sargent reinterprets Aestheticism on the basis of modernity, replacing the classically draped maidens of a Leighton or Moore with fair-haired girl-children who might have strayed from the pages of Kate Greenaway. The profusion

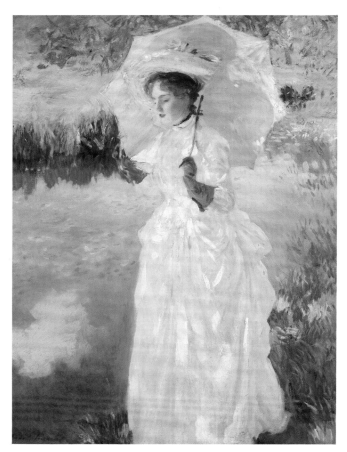

fig.38 *A Morning Walk* 1888
oil on canvas
67.3 × 50.2 (26½ × 19¾)
Private Collection

of flowers across the surface recalls the floral backgrounds of Burne-Jones's paintings, but evokes the lushness of a modern English garden rather than the stylisation of a medieval tapestry. Yet the garden's realism becomes haunting in the play of twilight and lantern-light, a transformational effect reminiscent of Whistler's description of dusk in his 'Ten O'Clock' lecture of 1885: 'when the evening mist clothes the riverside with poetry … and fairy-land is before us'.

The high viewpoint eliminates the sky and with it all suggestion of real-world scale, while the oversized flowers

tower over the children; as in *The Daughters of Edward Darley Boit* (fig.12), the play on scale evokes a childhood world. The moody shadows of the earlier picture have, however, disappeared in what may seem a cynical bid for the affections of an English audience addicted to 'sentimentalism', and indeed *Carnation, Lily, Lily Rose* has always been a public favourite (it was purchased by the Royal Academy under the terms of the Chantrey Fund and subsequently transferred to the Tate Gallery). But beyond its prettiness, there is a powerful coherence to the picture's treatment of childhood. The fragile beauty of the girls, the paper insubstantiality of the lanterns, the fleeting twilight effect, the full-blown flowers heavy on their stems, even the title's reference to a popular song of the moment – all hint at evanescence. However decorative its surface patterns, the picture rejects the aspirations to transcendence of British Aestheticism, whether in the form of Rossettian intensity or Leightonesque formal perfection. But the fugitive quality of the moment is not that of Impressionism either. The large scale of the picture (more than five feet by five), the close view and the strong contrasts provide not a glimpse but a fully described encounter with the depicted event.

In more informal subject pictures of the later 1880s Sargent seems paradoxically to move closer to mainstream Impressionism as we now understand it, as if his self-imposed distance from the Paris art world had encouraged him to reconsider his allegiances. Contact with British experiments in both Impressionism and Aestheticism perhaps offered fresh perspectives on the French style. Many writers have noted the resemblance between *A Morning Walk* (fig.38), exhibited at the New English Art Club in 1889, and Monet's painting of three years earlier, *Woman with a Parasol* (fig.39). Sargent would seem to have lifted parasol, dress and sunny outdoor setting wholesale from the French artist. At this time Sargent was working with Monet to raise money for the purchase of Manet's *Olympia* for the French national collection, and he was perhaps ruminating on the debates surrounding avant-garde painting. But Sargent's title, reminiscent of Gainsborough's famous double portrait *The Morning Walk* (1785, National Gallery, London), suggests an English perspective for his 'imitation'

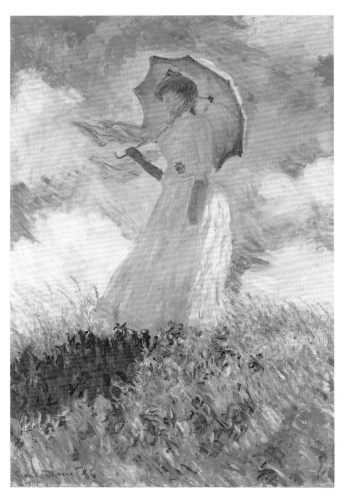

fig.39 Claude Monet, *Woman with a Parasol* 1886
oil on canvas 131 × 88 (51⅝ × 34⅝)
Musée d'Orsay, Paris

of French Impressionism. The closer view of the figure and the more definite facial features reinterpret Monet's composition, shifting the focus from atmospheric effect to the human figure, seen from a high viewpoint that eliminates the airy expanse of sky in the Monet. Sargent could convey brilliant light as effectively as his French colleague and his brushstrokes are if anything broader, but with the utmost subtlety of light and shade he reasserts the figure's solidity.

The practice of copying old masters was a familiar feature of traditional art education; here Sargent seems to be making what is virtually a copy of a contemporary master, as if trying on his clothes. The slightness of the changes constitutes their significance – like an art student, he makes the copy to test the usefulness of the adopted style to his own practice. The implied comparison to Gainsborough is not inappropriate for Monet's style in the 1880s, and still more relevant to Sargent's.

In a slightly later painting of the French portraitist *Paul Helleu Sketching with his Wife* (fig.40), Sargent represents his friend working in Impressionist fashion, out of doors; the individual colours of each blade of foliage constitute Sargent's closest approximation to the Impressionists' coloured patches. But again the high viewpoint encloses the scene and tilts the background up to the surface, reducing the sense of airiness characteristic of Impressionist landscape. Perhaps we can discern an interest in the decorative surface patterning of British Aesthetic artists such as Moore or Burne-Jones, but so thoroughly blended with the Impressionist subject matter that it becomes almost undetectable. Sargent's individual strokes are worked into a more structured pattern than usual in Impressionism; indeed, the formal agreement between the individual diagonal brushstrokes and the overall diagonal lines of the composition is much tauter than in either *A Morning Walk* or its French prototype. What appears at first sight a straightforward essay in a kind of landscape subject characteristic of the Impressionism of the 1870s proves to involve a more up-to-date search for formal order, comparable in a broad sense to the work of Seurat or Cézanne in the later 1880s.

In a purely technical sense the explorations of surface pattern in the subject pictures of the 1880s may have helped Sargent to develop his facility in constructing the bold weave of brushstrokes that would characterise his manner in the portraits of the succeeding decades. At the increased scale of a life-size portrait, the strokes become gigantic; indeed, they are virtually illegible at close range. The viewer is forced to step back until they resolve into a convincing illusion. Twentieth-century writers have often criticised the showy bravura of the brushstrokes and the surface glitter of the highlights, but that is only half the story. The pictures depend on a state of tension between the vivid illusionism of the portrait likenesses and the extravagant artificiality of the paint surface. As the viewer approaches and retreats from the picture, the illusion disintegrates and resolves in turn. Neither the realist illusion nor the painterly artifice emerges victorious; they are in constant play with each other.

Moreover, the interplay of painted surface and representational depth is also central to the social and psychological dimensions of the portraits. Masks and make-up are recurring images in late-nineteenth century Aesthetic and 'decadent' fiction and poetry. Max Beerbohm's essay of 1894, 'A Defence of Cosmetics', recapitulated Baudelaire's earlier eulogy of artifice. 'Too long has the face been degraded from its rank as a thing of beauty to a mere vulgar index of character or emotion', wrote Beerbohm. The passage was intentionally shocking, but also represented a serious protest against the practice, in earlier Victorian paintings and novels, of probing a figure's physiognomy for clues to moral character or emotional profundity. Instead Beerbohm called for cosmetics to mask the 'vulgar' under a beautiful surface. We have seen Sargent fascinated with literal make-up in the portrait of Virginie Gautreau. More generally, his portraits revel in the sitters' figurative make-up, the 'masks' they wear before the world, including marks of social status more or less artfully assumed. Sargent's creation of 'masks' for his sitters has frequently been dismissed as mere flattery. But perhaps this raises more serious questions about the relationship between superficial appearance and inward identity, parallel to concerns in contemporary literature and philosophy. Can we ever know another human soul or only the mask that conceals it? Sargent's bravura style is a fitting vehicle for exploring such questions; the powerful illusion of the sitters' presence, from a few feet back, dissipates into an incoherent flurry of surface marks when seen close up. Which, though, is the 'truth', the literal paint surface or the illusion conjured by the painter's artifices?

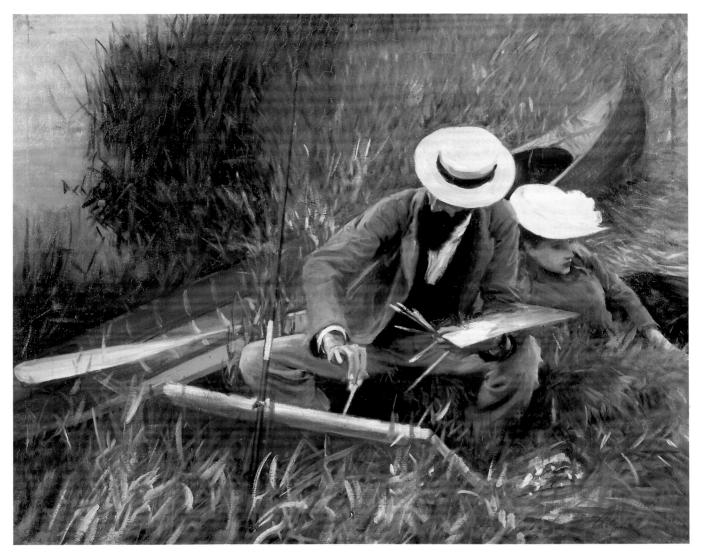

fig.40 *Paul Helleu Sketching with his Wife* 1889
oil on canvas 66.4 × 81.6 (26⅛ × 32⅛)
Brooklyn Museum of Art, Museum
Collection Fund

3 America

The Image of the American

Born in Florence of American parents, Sargent visited America for the first time at twenty, just in time to retain legal citizenship. But the Sargents' American connections were crucial to the painter's career, bringing important introductions and, above all, portrait commissions. The increasing cosmopolitanism of wealthy Americans can make it difficult to distinguish Sargent's American sitters from his British ones. Many of the titled women in Sargent's portraits were Americans who had married into the British aristocracy. But it may be possible to distinguish Sargent's American sitters, instead, by their looks.

Although Sargent had painted American sitters from the start of his career, beginning with family friends (see fig.6), it was a working trip in 1887–8 that consolidated his reputation as a major portraitist of Americans, and especially American women. Henry James prepared the way in his article on the painter, published in *Harper's Monthly* just as Sargent crossed the Atlantic. James called attention to two recent portraits of 'American ladies', distinguishing them from

> the curiously literal, prosaic, sexless treatment to which, in the commonplace work that looks down at us from the walls of almost all exhibitions, delicate feminine elements have evidently so often been sacrificed. Mr. Sargent handles these elements with a special feeling for them, and they borrow a kind of noble intensity from his brush.

Coming from the author of *Daisy Miller* (1879) and *Portrait of a Lady* (1881), the period's most compelling literary characterisations of the American woman, this was surely calculated to entice potential sitters. With utmost subtlety James promises women an image of their distinctively American sensuality, but one 'delicate' enough to satisfy good taste.

Sargent could make good on that promise, as in the portrait of *Isabella Stewart Gardner* (fig.41), whose black dress and pale skin recall *Madame X* (also, of course, an American; see fig.15). However, Gardner's lips and eyes are not emphasised by make-up; the delicate sfumato of her face is quite unlike the icy severity of Gautreau's. At forty-seven, Gardner appears more sensual than the youthful 'professional beauty'. Nonetheless, the exactly symmetrical pose, most unusual for Sargent, and the equally symmetrical gold textile forming a halo behind her, create what might be called an icon of female power, appropriate to a woman of considerable wealth and independence, the creator of the art collection still open to the public at her house in Boston. Apparently, the portrait did not please Gardner's husband, whether because of its eroticism or its suggestion of domination, but it did strike the French critic, Paul Bourget, as epitomising the American woman: 'the picture of an energy, at once delicate and invincible, momentarily in repose'. Gardner's energy is not the nervous tension of Mrs Hammersley or Mrs Thursby, dissipated in slashing diagonals and glancing highlights. Her self-contained pose suggests controlled and focused dynamism. Even the background of ordered circular patterns leads the viewer's eye inward to the figure, rather than zigzagging away as the carpets, draperies and gilded furniture do in many of Sargent's portraits of English sitters.

Gardner's pose is not only symmetrical but perfectly upright. A plumb-line from the crown of her head would exactly bisect her nose, chin, *décolletage*, the ornaments on the two strands of pearls at her waist, and her clasped hands. She faces forward with no turn or tilt. The stability and confidence of this pose could scarcely differ more abruptly from the precarious poses of so many of Sargent's English women. In general, Sargent used simple upright

fig.41 *Isabella Stewart Gardner* 1888
oil on canvas 190 × 81.2 (74¾ × 32)
Isabella Stewart Gardner Museum, Boston

poses much more often for American than for European sitters (see fig.47). Another example is the double portrait of *Mrs Edward L. Davis and her Son Livingston Davies* (fig.42); again the woman's gaze is perfectly level. The gestures with which the two figures twine their arms around each other appear fresh and informal, especially in the context of a grand, full-length portrait. The boy's stance is as jaunty as his spotless sailor suit and straw hat. But the grouping also suggests an easygoing family solidarity very different from the spatial dislocations in the portrait of *Mrs Carl Meyer and her Children* (fig.31).

Henry James's novels bolstered a stereotype already long familiar, that young American women were more independent than their European counterparts. Perhaps the most appealing example in Sargent's work was the portrait of Edith Minturn Phelps Stokes (fig.43). At first Sargent posed Stokes in an elegant evening gown, standard attire for female formal portraits (for example, figs.17, 32). Finally, he decided to paint her in the everyday clothes she wore for her brisk walk to his studio. In the later nineteenth century the question of women's attire was a subject of much debate, closely linked to the campaigns for women's rights. Dress reform movements urged women to abandon constricting corsetry and impractical fashions for the sake of emancipation in the widest sense. Stokes's practical clothes, highly unusual in a formal portrait, immediately identify her as a 'New Woman'. Her radiant face suggests brimming good health. Although she wears a belt at her waist, her figure is not constricted into the tight corseted hourglass of Mrs Hammersley. Stokes is as tall and slender as any of Sargent's sitters, yet her form under the roomy grey blouse and spreading white skirt retains freedom of movement. Again the pose is fully frontal and straight from head to toe and Edith Stokes appears in every sense well balanced, in contrast to her highly strung European contemporaries.

It was partly an accident that the husband, Isaac Newton Phelps Stokes, came to occupy a subordinate position in the portrait. The original plan had been for a portrait of Edith Stokes alone. Isaac planned to commission his own portrait from Whistler, but gave up the idea, apparently daunted by Whistler's fee. Sargent therefore inserted him into the back

fig.43 *Mr and Mrs Isaac Newton*
Phelps Stokes 1897
oil on canvas 214 × 101 (84¼ × 39¾)
The Metropolitan Museum of Art,
New York. Bequest of Edith Minturn
Phelps Stokes, 1938

fig.42 *Mrs Edward L. Davis and Her*
Son Livingston Davis 1890
oil on canvas 218.8 × 122.6 (86⅛ × 48¼)
Los Angeles County Museum of Art, Frances
and Armand Hammer Purchase Fund

corner of his wife's portrait. Perhaps the rather Whistlerian sketchiness of the background figure is a witty reference to Stokes's original plan. Taller than his wife, he presides with some authority in the background, but he does not dominate; it is she who occupies the bright foreground. The portrait makes a powerful image of the American New Woman, striding confidently forward from a background of quiet male authority, not yet forgotten but already subsiding into shadow.

Sargent's portraits of Americans remain well within the established European genre of grand-manner portraiture. Life-size, often full-length, deploying costume and accessories to convey the sitters' wealth and status, they reinterpret the portrait formulae of the European masters, from Velázquez and Hals to Reynolds and Gainsborough. During Sargent's lifetime there was constant debate about how 'American' he and his work were. Should not a truly American artist invent a new kind of portrait, one that abandons old-world traditions to create new images for a new world? In the twentieth century, too, Sargent has often been compared unfavourably to American portraitists who made their careers at home, such as Thomas Eakins, whose powerful portrait characterisations are seen to reject the glamour of European grand-manner portraiture in favour of searching psychological analysis (see fig.45). But there is no reason to value one artist above the other. Sargent's cosmopolitan style was ideally suited to projecting the new significance of modern Americans on the international scene; the Stokeses were wealthy New Yorkers living in Paris. Sargent gave his American sitters a distinctive public image, a 'mask' that announces equality with the grandest public manner of the old-world aristocracy.

Henry James

In Edith Stokes we seem to see the very incarnation of one of Henry James's American heroines, an Isabel Archer starting into vivid life. In the strange intensity of *Edouard and Marie-Louise Pailleron* (fig.13) we are forcibly reminded of *The Turn of the Screw*, and Sargent's British aristocrats can seem equally Jamesian. Sargent's friendship with James makes it irresistible to compare the works of the two expatriate Americans, who rose to dominate the worlds of European art and letters as their compatriots did those of international economics and finance. Many articles and books on Sargent therefore begin with scene-setting quotations from James. The most apt of these, perhaps, is the one that Trevor Fairbrother uses in the Preface to his important recent book on Sargent: 'We [Americans] can deal freely with forms of civilization not our own, can pick and choose and assimilate and in short … claim our property wherever we find it.' James's words make a virtue of Sargent's eclectic use of European portrait conventions and artistic styles. As Fairbrother notes, Sargent's (and James's) syntheses of European cultural tradition might be linked to America's expansionist policies at the end of the nineteenth century. But perhaps they also suggest that the distinctive eclecticism of the American can not only recycle fragments of the European tradition but emancipate them for new uses.

In another sense, though, the comparison between James and Sargent may seem profoundly inappropriate. If James's notoriously convoluted literary style is as attention-seeking in its way as Sargent's painting style, its obliquity and obscurity might rather be called the reverse of Sargent's extroversion. James paints character with a thousand delicate strokes of the pen, where Sargent sweeps one bold stroke of the loaded brush. James was, indeed, capable of annotating his own portrait by Sargent (fig.44) with the detail of one of his literary characterisations – self-consciously so, for he refers to himself, at first, in the third person:

> One is almost full-face, with one's left arm over the corner of one's chair-back and the hand brought round so that the thumb is caught in the arm-hole of one's waistcoat, and said hand therefore, with the fingers a bit folded, entirely visible and 'treated.' Of course I'm sitting a little askance in the chair. The canvas comes down to just where my watch-chain (such as it is, poor thing!) is hung across the waistcoat: which latter, in itself, is found to be splendidly (poor thing though it also be) and most interestingly treated.

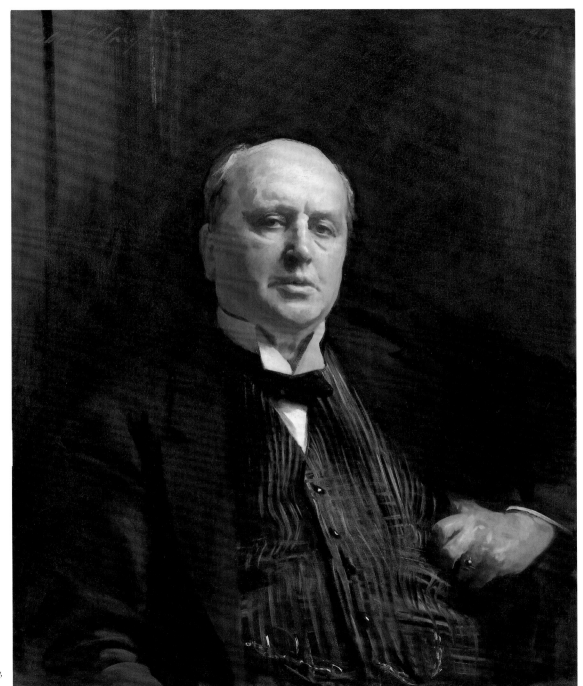

fig.44 *Henry James* 1913
oil on canvas
85.1 × 67.3 (33½ × 26½)
National Portrait Gallery,
London

As well as noting the 'askance' pose so typical of Sargent's portraits, James makes psychological drama of the apparently minor detail of his own watch-chain. By calling it a 'poor thing' he shows how Sargent can indicate just such nuances of social status as his own descriptions could hint: this is the accessory of a man of some professional standing, yet not a sign of wealth or luxury. James detaches himself from his own hand, but invests it with significance. The folding of the fingers and the thumb in the arm-hole strive for nonchalance but achieve complexity, each finger describing its own curve in an involuted form that might be symbolic of James's prose style. But is James reading too much into his own portrait? Is he projecting his own habits of nuanced characterisation onto a painter who, according to his standard reputation, had little insight into character beyond the clever recording of a likeness?

Psychological Profundity

Given the habit of comparing Sargent to James, it is paradoxical that the most tenacious criticism of Sargent's work has been its supposed lack of psychological profundity. Yet the charge has been repeated so frequently that it requires an effort of will to step back and ask what it may mean. Why are we so sure that we can see deep into Rembrandt's psychology, when we look at his self-portraits, yet feel we cannot do the same with Sargent's portraits? On reflection the question proves much more complicated than it first appears.

The expectation that a portrait will probe the sitter's private depths is recent, and indeed postdates Sargent's career, at least in its fully developed art-historical form. There is scarcely a hint of it in John Collier's textbook on *The Art of Portrait Painting*, published in 1910. For Collier the distinctively 'modern' requirement for portraiture, as opposed to the idealised formality of medieval and Renaissance portraiture, is the projection of a 'speaking likeness', communicating the sitter's vitality to the viewer. This conveys character, not by delving into the sitter's psyche, but in an extrovert way that, as Collier notes, may even verge on caricature. It is scarcely surprising that Collier held Sargent's portraiture

in high esteem. But within a few years, and before Sargent's death, a significant shift in critical criteria was becoming evident. The title of Claude Phillips's book of 1925 is revealing: *Emotion in Art*. Phillips, formerly art critic for the *Daily Telegraph* and Keeper of the Wallace Collection, was no hot-headed avant-gardist, but a respected figure in the professional world of art criticism and administration. His view has remained the standard interpretation of Sargent ever since:

> Nothing is more disappointing than the absence of the deeper human note in the work of one of the greatest living masters of the brush – *the* greatest, I had almost said – Mr. J.S. Sargent … He prefers, as we must infer, to keep humanity at arm's length; to sum up its physical and mental characteristics, without any delving into hidden depths … to study its outward appearances with a keen but never-malevolent curiosity; to fasten upon those points which he deems vital and expressive, and by emphasizing them, to amuse himself, and relieve with a sharp and stimulating accent of his own the monotony of the human individuality in its modern aspects and developments.

To seek psychological profundity, or what Phillips calls 'hidden depths', in Sargent's portraiture is, then, to impose a criterion that appeared in art criticism only toward the end of Sargent's lifetime. By that time, too, Freudian notions of the unconscious were becoming familiar in England and America, popularising the notion that the most significant aspects of human identity are precisely those which are hidden, not just from the casual observer, but often from the self. Portraits such as Eakins's (fig.45), where the sitters seem to brood on deeply personal feelings, have proved more appealing to many in the post-Freudian twentieth century than Sargent's more dashing displays of his sitters' public personae.

These observations, however, can only suggest what we might find lacking in Sargent's characterisations. Are we therefore to conclude, as so many critics and art historians have done, that Sargent's portraits are psychologically

vacuous? One possibility is to answer yes, but without rancour. Perhaps the fascination of Sargent's portraits is precisely with the concealment of inner depths that characterises 'sociability' rather than self-centred soul-searching. Sargent's lifetime coincided not only with the early days of psychoanalysis but with the development of sociology as a university discipline. In an essay of 1910 the German sociologist Georg Simmel described 'sociability' as that aspect of social interaction that leaves aside the personal interests and motives of individuals:

> This exclusion of the personal reaches into even the most external matters; a lady would not want to appear in such extreme *décolletage* in a really personal, intimately friendly situation with one or two men as she would in a large company without any embarrassment. In the latter she would not feel herself personally involved in the same measure and could therefore abandon herself to the impersonal freedom of the mask.

Formal portraits such as those of Gautreau, Gardner or the Wyndhams place their sitters in just such a 'large company', where they are not obliged to relinquish their privacy, however revealing their *décolletages*. The pictures perhaps deploy upper-class customs as symbols of the sociability that Simmel describes as an 'ideal sociological world, for in it the pleasure of the individual is always contingent upon the joy of others; here, by definition, no one can have his satisfaction at the cost of contrary experiences on the part of others'. By contrast, pictures such as Eakins's might be accused of denying sociability, inviting the viewer to trespass on the sitter's privacy or even to identify with an antisocial world of narcissistic self-absorption.

We have seen that critics and audiences did not necessarily accept the pure 'sociability' of Sargent's portrait characterisations: Gautreau's *décolletage* did cause her embarrassment, as perhaps did Gardner's. Such cases were few in Sargent's lifetime, but they suggest another aspect of psychological characterisation. Although critics did not necessarily look for 'hidden depths' in the post-Freudian sense, they did scrutinise portraits for what Henry James's

fig.45 Thomas Eakins, *Portrait of Mrs Edith Mahon* 1904
oil on canvas 50.8 × 40.6 (20 × 16)
Smith College Museum of Art,
Northampton, Massachusetts

brother, the psychologist William James, called the 'social self', or 'the recognition which he gets from his mates':

> Properly speaking, *a man has as many social selves as there are individuals who recognize him* and carry an image of him in their mind … But as the individuals who carry the images fall naturally into classes, we may practically say that he has as many different social selves as there are distinct *groups* of people about whose opinion he cares.

The Gautreau portrait projected a 'social self' that did not please the sitter, and more so, perhaps, as it was recognised

so easily by a group of people about whose opinion she cared. But it was Sargent's special skill to fashion images that not only matched the sitters' own sense of their 'social selves', but were ordinarily recognised as such by the groups to which they were addressed. This must have been a crucial source of the 'life-like' effect so often noted in contemporary criticism of Sargent's portraits. The representations of the sitters seemed uncannily to match the social selves they were expected to project in real life.

William James's *Principles of Psychology*, first published in 1890, made a major contribution to the emerging discipline of psychology, although its fame was subsequently overshadowed by Freud and European psychoanalysis. Already in 1890, James associated the notion of the 'pure ego' with German psychology, but that was only one element in his own account of the psyche. He did not accord unique status to 'hidden depths' but gave important roles not only to the 'social self' but to the 'material self', including our bodies, clothes and even property. Sargent's portraits seem closer to this kind of psychology than to the Freudian psychology now more familiar. Moreover, James's notion of human identity is more flexible and even precarious than the emphasis on 'hidden depths' he attributes to German psychology. Where Freudian psychoanalysis seems to offer the possibility of discovering the most meaningful, inward self, James's psychology suggested that we might have any number of selves, material, social and spiritual. In the passage quoted above he even suggested that we might construct a different social self for every different acquaintance. This sense of a plurality of possible selves might be associated with a distinctively American sensibility. The American emerging on the international stage might be able to project any number of selves, to 'pick and choose and assimilate', as Henry James had put it, from among the available options. Sargent has often been accused of flattering his sitters; perhaps, though, he was offering them the choice of the 'social self' they wished to project.

As William James thought, 'the most puzzling puzzle with which psychology has to deal' is our sense of personal identity. How is it that we feel ourselves to be the same unique person throughout all the myriad changes of our

fig.46 Marie Leon, *Henry and William James c.*1908
bromide print 20.1 × 15 (5⅞ × 7⅞)
National Portrait Gallery

mental life and indeed our physiological existence, when our blood vessels, heartbeats, glands and viscera are constantly in a state of flux? For the purposes of psychology, at least, James rejected the theological notion of an eternal soul, existing somewhere over and above the flux of our mental and sensory experiences. But he also rejected the idea that the flux was a merely random collection of events. James devoted much attention to the 'stream of consciousness', already a familiar concept in nineteenth-century psychology. Although our consciousness of ourselves is constantly changing, we experience the succession of our momentary selves as continuous, flowing like a river. The 'I' or 'me', as James asserts, is 'a *Thought*, at each moment different from that of the last moment, but *appropriative* of the latter, together with all that the latter called its own'. In James's theory the self can be posited at any moment in the stream, as an identity that is substantial both physically and mentally. At any moment, too, it can gather into itself the history of its own stream of consciousness. But for James it cannot be theorised outside the stream or apart from time. Its coherence is powerful but constantly reformulates itself as the stream flows.

Henry James's complex prose takes a cue from his

brother's research, tracing the streams of his characters' consciousness through all of their minute fluctuations (fig.46). But painting cannot so easily represent a stream of events; instead Sargent's portraits seem to give us the sitter at one point in the stream. According to William James, every mental change is accompanied by a physical one. The sitter's physical appearance at any moment may then bear the traces of the whole history of her or his consciousness. But in James's psychology, this appearance could not be final or eternal – it would give way immediately to a new moment in the flow. The 'momentary' appearance of Sargent's portraits, so evident to contemporary viewers, might be described as acknowledging the transience of any moment in the stream. To pretend to fix a permanent identity for the sitter, valid for all eternity, would be to deny the flow of the stream. This helps to mark the difference between Sargent's portraits and the 'timeless' aspect for which more traditional portraiture strives.

On the other hand, Sargent's portraits also convey a powerful sense of the sitter's substantial presence at the particular moment selected from the stream (fig.47). They do not dissolve the sitter into a play of fragmentary sensations of light and colour, as some Impressionist portraits might be said to do. The portraits simultaneously assert the coherence of the sitter's identity, in fully modelled light and shade, and the time-bound character of this same identity, valid only for the present moment in the stream. Sargent's portraits might then be said to be psychologically meaningful after all, not in the post-Freudian sense of probing 'hidden depths', but in the William Jamesian sense of conveying the sitter's compelling selfhood within the stream of consciousness.

The Private Life

The frequent charge that Sargent failed to plumb the psychological depths of his sitters finds an uncanny parallel in the contention that Sargent himself was unfathomable, even that he had no personal life at all. In some accounts this is presented as the corollary to his expatriation. As an American perpetually away from home, he was always an

fig.47 *Miss Elsie Palmer* 1889–90
oil on canvas 190.8 × 114.6 (75⅛ × 45⅛)
Colorado Springs Fine Arts Center,
Colorado, USA

outsider, detached from the societies where he lived only as a visitor. Indeed, his biographers have had little option but to concentrate on chronicling his travels. The late painting *The Hotel Room* (fig.48) might serve as a symbol of Sargent's elusiveness. The jumble of luggage on the floor suggests a temporary stay. The spontaneous brushwork and bold highlights capture what ought to be an intimate moment, but the room is devoid of human presence.

Sargent, like Henry James, never married and seems never to have had a significant relationship with a woman. The possibility that he was homosexual, treated gingerly in

fig.48 *The Hotel Room* c.1906–7
oil on canvas 60.9 × 44.4 (24 × 17½)
Private Collection

earlier writing on Sargent, was advanced more openly in Trevor Fairbrother's monograph of 1994. Fairbrother eloquently describes Sargent's fascination with the male body, evident in informal works such as *Nude Male Standing* (fig.49). Some of those who met Sargent, such as the American art historian and connoisseur Bernard Berenson, wrote of him in terms that hinted at homosexuality. We might, then, enrol Sargent among a number of American creative artists for whom homosexuality, whether publicly acknowledged or not, has been seen as a significant motive for artistic expression: Herman Melville, Walt Whitman, Henry James himself. If it is difficult to discern specifically homosexual content in much of Sargent's work, we might interpret his fascination with his sitters' social 'masks' as explorations of the psychology of concealment forced on nineteenth-century homosexuals.

We cannot, however, decide the issue of Sargent's sexuality; he preserved his own privacy too carefully. There is a danger, too, of recasting the myth of his missing private life into another myth of repressed homosexuality. As Fairbrother observes, a patronising characterisation of Sargent as fundamentally repressed is quite at odds with the extrovert quality of his painting. Nor do we need to see his legendary addiction to his work as a sign of sublimation. Perhaps the anecdotes of Sargent's indomitable energy are another kind of myth-making. Certainly they draw on the stereotype of the driving, compulsive industriousness of the American, emerging in the late nineteenth century to conquer the world as he had tamed the frontiers. Nonetheless, such anecdotes capture something important about Sargent's art.

A caricature by Max Beerbohm shows Sargent at work (fig.50), dashing energetically toward his canvas despite the portliness of his middle age, with a thick brush in either hand; he listens to the music of a string trio while an aristocratic woman in flowing robes poses in the background. The caricature encapsulates countless accounts of Sargent's working procedure, throughout his career. Descriptions, for instance, of Sargent's work on *Carnation, Lily, Lily, Rose* in the 1880s (fig.37) already stress his single-minded energy. As the writer Edmund Gosse recalled, Sargent made his

fig.49 *Nude Male Standing* 1890–1924
charcoal on paper 61.9 × 48 (24⅜ × 19)
*The Philadelphia Museum of Art. Gift of
Miss Emily Sargent and Mrs Francis Ormond*

fig.50 Max Beerbohm, *Mr Sargent at Work*,
frontispiece from *The Book of Caricatures*,
London 1907

materials ready for the fleeting moment when the light effect was right for the picture:

> Instantly, he took up his place at a distance from the canvas, and at a certain notation of the light ran forward over the lawn with the action of a wag-tail, planting at the same time, rapid dabs of paint on the picture, and then retiring again, only, with equal suddenness, to repeat the wag-tail action.

Although Sargent was painting a subject picture, this was the working procedure of a portraitist, as described in contemporary manuals such as John Collier's *The Art of Portrait Painting*. To capture a likeness at the size of life, the recommended procedure was to place the canvas next to the sitter, but the artist needed constantly to retire to see both sitter and canvas whole, dashing in to place strokes on the canvas, then retreating again to view the effect. The activity must have been tiring, but helps to explain how Sargent achieved the compelling coherence of his surfaces when seen from a distance, even though the weave of brushstrokes appears abstract from a close view.

In Collier's account the working practice of the portraitist is arduous not only because of the necessity for constant movement, but because of the rapidity required to create the image before the sitter tired:

> It is very disastrous if the sitter gets bored; and if the artist gets bored too, it is simply fatal … Therefore, the portrait painter must do his work at high pressure, must never waste his time, and must, if possible, prevent his sitter from getting bored.

Hence the string trio in Beerbohm's caricature. The twentieth-century art theorist R.G. Collingwood extended this mythology about the portrait painter's practice:

> A great portrait painter, in the time it takes him to paint a sitter, intensely active in absorbing impressions and converting them into an imaginative vision of the man, may easily see through the mask that is good enough to deceive a less active and less pertinacious observer, and detect in a mouth or an eye or the turn of a head things that have long been concealed.

Collingwood, writing in the 1930s, takes for granted the need for psychological penetration in portraiture. But the philosopher's account also suggests an answer to the frequent criticism that Sargent's rapid execution led to superficial results. The intensity of concentration required for work under 'high pressure', in Collier's phrase, may 'convert', in Collingwood's, into imaginative insight.

Late Work: Public and Private

In view of his exceptional skill at rapid, spontaneous work, Sargent's decision to diversify into monumental mural painting seems bizarre, even irrational. Still more unexpected are the subjects and approaches he chose for his two major commissions in American public buildings. In both cases he perhaps subordinated his personal predilections to an ideal of public service, devising programmes suited to the educational aims of the two institutions that commissioned him: the first library to be supported by public funds, and one of America's great public art museums. For the murals executed at the Boston Public Library between 1890 and 1919 Sargent actually abandoned an early plan to represent scenes from Spanish literature, well adapted to his own interest in Spain, in favour of what seems a strange subject for a man who by all accounts was never devout: *The Development of Religion from Early Beliefs*. More curious still, for the artist who had unequivocally rejected the French academic emphasis on classicism, was the array of mythological and allegorical subjects set into an icily grand neoclassical framework at the Museum of Fine Arts in Boston. A first series, for the museum's rotunda, occupied Sargent from 1916 to 1921 and was immediately followed by another set for the adjoining staircase, completed just before Sargent's death in 1925.

In abrupt contrast to these monumental projects was the other activity that dominated the last decades of Sargent's professional life, the remarkable outpouring of informal landscape and figure pictures in both oil and watercolour, in a flow that seemed if anything to accelerate after 1900. Eventually his production in these categories amounted to some 1500 works, generally small in scale by Sargent's standards but seemingly irrepressible in spontaneity and inventiveness. As Sargent gradually retired from the stress of his portrait practice, he travelled extensively with family and friends, spending the summer and autumn months in an array of holiday spots favoured by both expatriate Americans and leisured Europeans, ranging from Alpine mountains to Mediterranean islands.

The two categories of Sargent's later career seem diametrically opposed: grand murals, requiring arduous research and preparation, and spontaneous studies, capturing a natural scene or light effect. The latter are still more conformable to popular taste addicted to 'impressionistic' spontaneity and brilliant colour; it might be argued, too, that they were better adapted to Sargent's special skill for rapid execution or what Henry James had called his 'pure tact of vision'. The former are more difficult to interpret. Some writers have seen them as mistaken attempts to import traditions of European monumental painting into America, alien in subject and style to the New World, and outmoded even in the old one.

Yet we may ask whether it was not the landscape and figure studies that were more *retardataire* in the early twentieth century. If Sargent was never a thoroughgoing Impressionist, the late studies still work in a broadly impressionistic mode. They are at least as brilliant and fresh as most French work of the 1870s and 1880s, and indeed more various in their settings. But by the early twentieth century Impressionism was old-fashioned; although Renoir and Monet were still living, their claims to radicalism had been superseded by the 'Post-Impressionist' generation of Cézanne and Gauguin, and by still younger artists such as Matisse and Picasso. Sargent's famous contretemps with Roger Fry, the organiser of the pioneering Post-Impressionist exhibition of 1910, suggests that the artist, by now in his fifties, could not keep pace with new trends in avant-garde art and taste. In response to an article in the *Nation*, where Fry had attempted to enlist Sargent's support for his efforts, Sargent repudiated all sympathy with Post-Impressionism. His letter was printed on 7 January 1911: 'The fact is that I am absolutely sceptical as to [the pictures in the Post-Impressionist exhibition] having any claim whatever to

being works of art.' This incident has entered art history as a sign of Sargent's irredeemable conservatism, apparently confirmed by his continuing commitment to a broadly Impressionist manner for his late landscapes and figure studies.

Sargent's many late studies of Venice, which he visited almost every autumn in the first decade of the twentieth century, are in some ways more conventional than his early scenes of Venetian interiors and back streets (see fig.5). He returns to traditional tourist spots such as Santa Maria della Salute (fig.51) and to an emphasis on the dazzling light of the city suited to the watercolours that he employed as adeptly as his more familiar oil medium. Such pictures easily find a place in the tradition of painting views of Venice that extends back to J.M.W. Turner but was still very much alive. Sargent's contemporary, Walter Sickert, also painted multiple views of famous Venetian sites. They were exhibited and marketed much as Sargent's works, in single-artist shows in dealer's galleries such as the Carfax Gallery in London, which held the first solo show of Sargent's more informal work in 1903 and also dealt extensively in Sickert's paintings. Sargent's Venice was sunnier and brighter than Sickert's moodier scenes, often featuring the same monuments. Each artist was offering an instantly recognisable product; collectors could choose between Sargent's Venice or Sickert's Venice. Sargent was, then, keeping up with the times in making adept use of the latest channels for showing and marketing work. In the early twentieth century large numbers of his studies were acquired directly from his solo shows by American museums eager to build collections of an artist by then a national hero.

But the motive for Sargent's prolific production of studies can scarcely have been purely commercial. He did not need the income as Sickert did. Indeed, the range of his late studies is more diverse and experimental than Sickert's work of the same period. If the works were painted partly for pure pleasure, they continued to explore new possibilities. In an intriguing series painted in the Alps from 1907 onward, Sargent posed his holiday companions in exotic Orientalist costumes, creating a fantasy world that defies rational explanation. *The Chess Game* (fig.52) presents two male

fig.51 *Santa Maria della Salute* 1904
watercolour on paper 46 × 58.4 (18⅛ × 23)
*Brooklyn Museum of Art, Purchased by
Special Subscription*

figures, exotically costumed and reclining with the languor of Orientalist stereotype. The vibrant colours of Orientalist costumes and Alpine landscape mingle so that the viewer forgets the improbability of their juxtaposition.

The strong sense of mood in Sargent's late studies, the touches of fantasy and occasional hints of enigmatic narrative, have affinities with the late-nineteenth and early-twentieth-century artistic projects associated with the term Symbolism, despite their allegiance to a broadly Impressionist method of design. However, the mural projects mark a more thoroughgoing new departure in Sargent's work. If their thematic emphases, scriptural and classical, appear at first thought typical of old-fashioned academic practice, neither cycle develops these themes in the orderly fashion that we would expect in a traditional mural programme. Indeed, they have often been criticised for failing to offer clear didactic messages, appropriate to the institutions that commissioned them. Both cycles are concerned less with specific messages than with broader notions of human culture and its reputed origins in the distant past, parallel to the concerns of contemporary sociological and

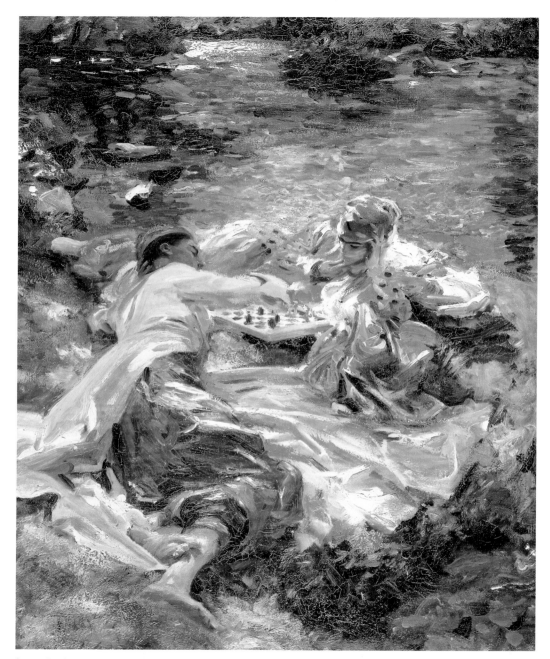

fig.52 *The Chess Game c.*1907
oil on canvas 69.9 × 55.3 (27½ × 21¾)
Harvard Club of New York

anthropological research. In style, too, they explore new interests in the primitive and archaic, employing decorative modes that have closer affinities with contemporary Symbolism, French Art Nouveau and German Jugendstil than with traditional academic practice.

The Boston Public Library murals dramatise a sweeping symbolic survey of religious beliefs, opposing pagan and Christian religion on the two end walls of a long barrel-vaulted chamber. Sargent's work at the library covers almost exactly the same time span as Sir James Frazer's *The Golden Bough* (issued in twelve volumes from 1890 to 1915). Like Frazer's scheme, Sargent's emphasises the comparative study of different religions as well as a historical progression through different phases of belief; the stress on early religions also recalls the work of the sociologist Emile Durkheim, whose influential book *The Elementary Forms of Religious Belief* appeared in 1912. The vault of the Pagan End (fig.53) makes visible a comparative scheme of ancient religions. Spanning the entire vault is the shadowy body of Neith, an Egyptian sky goddess, her feet and hands touching the cornice on either side, her dark face visible amidst the superimposed forms of other deities. The sun god Moloch, crushing men with his four hands, serves as a masculine principle balanced by Astarte, the moon goddess, the victims of whose sensuality writhe beneath her pale blue garments. The vault also contains a Zodiac, a mummy, the shadowy figures of the Egyptian Trinity (Isis, Osiris and Horus) and a host of other pagan symbols. Sargent finds a new style, startlingly unlike the vivid spontaneity of his portraiture, to monumentalise his symbolic figures. The dizzying changes of scale and the crowding of images one on top of the other are overtly non-realistic; the multiplication and juxtaposition of symbolic creatures on the overarching vault is awe-inspiring. On the opposite wall, the Christian End represents a new phase of belief, but not necessarily a progressivist triumph. The two groups of murals have equal visual weight, and the Byzantine stylistic mode of the Christian End repeats the archaism of the Pagan End in a different form. Between the two ends, further paintings on the vault and side walls elaborate the comparative juxtaposition of pagan and Christian dogmas.

fig.53 Vault of the Pagan End, Boston Public Library

fig.54 The rotunda at the Museum of Fine Arts, Boston

The murals in the rotunda and staircase of the Museum of Fine Arts inhabit a more structured architectural setting (fig.54), but the subjects lack the comparative and progressive logic of the library programme, and indeed seem only loosely unified: the oval paintings of the rotunda involve allegorical representations of the arts, while the staircase murals include figures of Philosophy, Science and Truth, and paintings in the adjoining corridor represent the deeds of mythological heroes. The style is starker and simpler than that of the library, silhouetting delicately modelled classicising figures against plain backgrounds in the manner of antique cameos and gems. Both the visual reminiscences of classical art and the subjects' references to classical legend are curiously abstracted from their usual contexts, as if

fig.55 *The Sphinx and Chimera* 1916–21
oil on canvas
302.6 × 234.3 (119⅛ × 92¼)
Museum of Fine Arts, Boston, Francis Bartlett Donation of 1912

they are being presented afresh to a new world that will need to reinvent their meanings. Perhaps the assemblage of fragmentary references can be interpreted as symbolising the museum's mission of preserving isolated artefacts from past civilisations. The inclusion of the sphinx in one of the rotunda murals, *Sphinx and Chimera* (fig.55), is appropriate for a museum that housed one of America's finest collections of Egyptian antiquities, but puzzling as part of the overall programme. Perhaps the sphinx, mythological symbol of secret knowledge, and the fantastic chimera deliberately introduce a note of mystification, their kiss suggesting a strange union of incongruities. In this composition in particular, but more subtly in the cycle as a whole, ancient mythology does not yield the eternal meanings of the Western tradition of mural painting but preserves its primeval secrets, despite the formal lucidity of the neoclassical stylistic mode.

Both mural cycles explore contemporary conceptions of the origins of human culture, in the sphere of religion at the library and of aesthetics at the museum. As in much contemporary scholarship, the emphasis is on the remoteness of cultures predating modern rationalism. Neither cycle uses American imagery. Nonetheless, the preoccupation with cultural origins is appropriate in a broad sense to a country creating its own new cultural institutions, such as the library and the museum. Sargent's murals have not yet succeeded in capturing the popular imagination; to that extent they might be called failures, while his late landscape and figure studies are brilliant successes in more approachable pictorial categories. However, the ambition and, indeed, the originality of the mural projects should not be underestimated.

Sargent was in the Austrian Tyrol on one of his painting holidays when war broke out in 1914, leaving him and his companions behind enemy lines. A haunting watercolour, *Graveyard in the Tyrol* (fig.56), suggests the atmosphere of foreboding in those first months of World War I. Nearly four years later Sargent was commissioned by the War Artists Committee. Appropriately, his task was to commemorate collaboration between American and British soldiers in a monumental mural painting. For practical

reasons the final picture depicted British soldiers alone, but the subject recorded an experience shared by all nationalities, a line of gassed men proceeding blindfolded to a medical station (fig.57). Sargent reverts to the realist mode of his portraiture, recording up-to-date details of military costume and weaponry in a subdued version of his bravura style, appropriate to the vast scale of the twenty-foot canvas as well as the serious subject matter. Here the recondite allusions of the American mural cycles would have been out of place. But with utter simplicity the frieze-like composition, silhouetting a line of soldiers against the sky with the rhythm of an ancient vase or bas-relief, makes the analogy between the modern soldiers and classical heroism.

fig.56 *Graveyard in the Tyrol* 1914
watercolour on paper
34.6 × 53 (13⅜ × 20⅞)
The British Museum

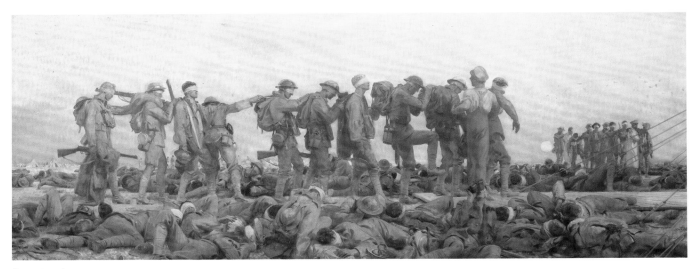

fig.57 *Gassed* 1919
oil on canvas
231 × 611.1 (91 × 240½)
Imperial War Museum, London

4 The Modern Art of Portraiture

By the time of Sargent's death in 1925 the reputation that had once seemed unassailable was in a decline as precipitous as that of the class to which his name was irrevocably linked. Many visitors to Sargent's memorial exhibition now found the portraits' upper-class glamour unpalatable. But it was not only leisure-class privilege that lost its appeal in the post-war world. The rising anti-Semitism of the 1920s suggests a more sinister kind of intolerance. If Sargent's celebrations of Jewish prosperity and success came under particular attack, that may be only the most unpleasant sign of a post-war loss of confidence in the social dream of a rapidly diversifying, potentially limitless upper class that Sargent's portraits had successfully projected in the more optimistic world of the late Victorian and Edwardian periods.

However, the most damaging attacks on Sargent came from a position that claimed ideological neutrality, denying Sargent's greatness on grounds of sheer artistic quality. In the last decades of Sargent's life it was increasingly the rule for champions of 'avant-garde' or 'modernist' art to disparage his aesthetic achievement, even as they acknowledged his technical brilliance. Sargent might be described as a victim of his own success, arousing envy with his dazzling technical facility. But there is something curiously intemperate about the criticisms, a vehemence that perhaps masks a hint of unease about the judgements. And, indeed, the judgements are systematically paradoxical. Almost invariably they oscillate between two extremes, hyperbolic admiration for Sargent's technical accomplishment and equally excessive repudiation of his claims to artistic greatness. Roger Fry's stinging comments on Sargent's memorial exhibition, particularly influential after they were reprinted in his volume *Transformations* of 1926, eloquently expressed the standard grounds for complaint: 'Wonderful

indeed, but most wonderful that this wonderful performance should ever have been confused with that of an artist.'

Fry's accusation turns against Sargent's own work precisely the charge Sargent had levelled at the pictures in Fry's Post-Impressionist show: that they are not art. But this was not just a personal vendetta, for Fry's accusation involves the most basic issue in the theory of portraiture, the relationship between the utilitarian function of capturing a likeness and the aesthetic quality of the portrait as a work of art. In his essay 'Sargentolatry' Sickert described the portraitist's work as 'a compromise between what the painter would like to do and what his employer will put up with'. Collingwood, attempting to formalise this practical distinction into a theoretical principle, carefully distinguished between the portrait's status as representation and its status as work of art: 'A representation may be a work of art; but what makes it a representation is one thing, what makes it a work of art is another.'

The elevation of aesthetic quality over representation or likeness has roots in earlier art theory, but as elaborated by writers such as Fry and Collingwood it becomes inseparable from the modern theory of 'formalism', the elevation of abstract form or design over subject matter or representation. On a literal interpretation a portrait can never be a perfect work of art in formalist terms, since some kind of representational likeness is an irreducible requirement. It is no surprise, then, that the few works by Sargent that Fry permitted himself to praise are not portraits. The exquisite early essay in an Impressionist mode, *Wineglasses* (fig.58), met Fry's demands for formal perfection: 'that particular pleasure which I look for in pictures, namely, the delight in certain visual relations regarded in and for themselves.' Fry also remembered the powerful impact Sargent's sketches of

fig.58 *Wineglasses c.*1875
oil on canvas 45.7 × 36.8 (18 × 14½)
Private Collection

the modern here-and-now; the dramatisation of social flux as opposed to the petrification of social status; the projection of the social self; the crystallisation of the present moment in the psychological stream of consciousness; the play between surface artifice and realist illusion. *Ena and Betty, Daughters of Asher and Mrs Wertheimer* (fig.60) can sustain all of these interpretations. From close range the play of gigantic brushstrokes flattens into pure painterliness, yet from a distance the 'speaking likenesses' start from the picture space. The glittering highlights on the white dress, the gleaming vase and the summarily foreshortened fan are readable in turn as symbols of the Wertheimers' Jewish opulence or abstract patches of luscious pigment. Sargent here meets both of Collingwood's criteria for a portrait, but without Collingwood's divisiveness. What makes this portrait a representation is precisely what makes it a work of art.

Javanese dancers had made on younger artists when they were exhibited at the New English Art Club in 1891 (fig.59). The suggestion of primitivism in these sketches was more appealing than the skilful polish of Sargent's finished pictures to an early twentieth-century sensibility like that of Fry, who sought radical alternatives to the sophistication of the Western mainstream tradition in unfamiliar aesthetic forms such as African and Byzantine art, as well as the formal simplifications of Cézanne and Gauguin.

But Sargent's work cannot be adequately judged according to the criteria of formalism or modernism. *Wineglasses* and *Javanese Dancer* are superb examples of their respective kinds, but they are not central to Sargent's achievement. The works that mark Sargent's special contribution to the history of art are his portraits. In the preceding pages we have explored a number of possible interpretations of what distinguishes them from the works of other artists and other ages: the powerful projection of the sitter's presence, not in the timeless realm of traditional portraiture, but in

fig.59 *Javanese Dancer* 1889
oil on canvas
172.2 × 80 (68 × 31½)
Private Collection

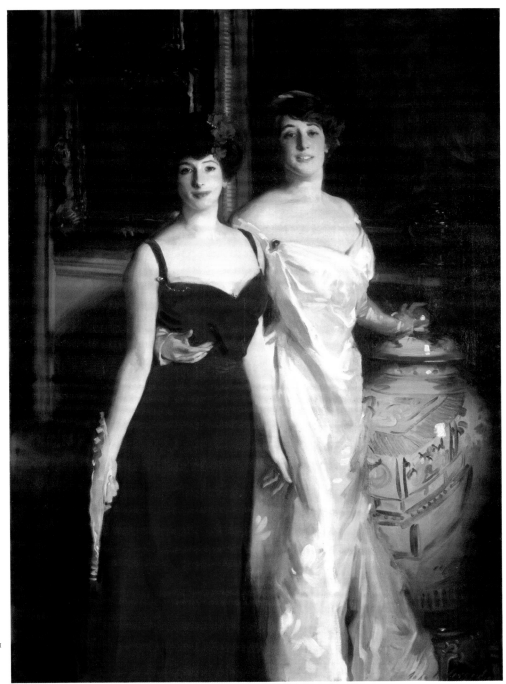

fig.60 *Ena and Betty, Daughters
of Asher and Mrs Wertheimer* 1901
oil on canvas
185.4 × 130.8 (73 × 51½)
Tate Gallery

Chronology

1856
John Singer Sargent born in Florence, 12 January, to American expatriate parents, Dr Fitzwilliam and Mary Newbold Singer Sargent

1874
Sargent family moves to Paris; first 'Impressionist' group exhibition; Sargent enrols in atelier of Carolus-Duran and drawing classes at Ecole des Beaux-Arts

1876
Sargent's first journey to his native America; visits Centennial Exhibition in Philadelphia

1877
Makes Salon début with *Frances Sherburne Ridley Watts* (fig.6); summer in Cancale, Brittany

1878
Shows scenes of Cancale at the Salon, Paris (fig.3), and the first exhibition of the Society of American Artists, New York; summer in Naples and Capri

1879
Portrait of *Carolus-Duran* (fig.1) wins Honourable Mention at the Salon; autumn in Spain, crossing to Morocco in December

1880
Travels in North Africa, the Netherlands and Venice (through to early 1881)

1881
Wins Second Class Medal in first Salon administered by the Société des Artistes Français (after French government relinquished control of the Salon in 1880)

1882
El Jaleo (fig.10) and a portrait at Salon; *Dr Pozzi at Home* (fig.19) at Royal Academy, London; also shows at Grosvenor Gallery and Fine Art Society, London; henceforth Sargent's career is fully international, covering major exhibition centres in USA and Europe; summer in Venice

1883
Takes studio at 41 boulevard Berthier, Paris (see fig.18)

1884
Portrait of Virginie Gautreau (fig.15) creates *éclat* at Salon; visits England

1885–9
Summers with friends in English rural villages (Broadway, Calcot Mill, Fladbury), where he paints out of doors; visits Monet at Giverny

1886
Moves to London; takes studio in Tite Street, Chelsea (see fig.21); shows in first exhibition of New English Art Club

1887
Carnation, Lily, Lily, Rose (fig.37) at Royal Academy, and purchased by Chantrey Fund; travels to America to undertake portrait commissions (through to spring 1888); Henry James's article publicises Sargent in *Harper's New Monthly Magazine*

1888
First solo exhibition at St Botolph Club, Boston; R.A.M. Stevenson's article on Sargent in *Art Journal*, London

1889
Receives medal at Exposition Universelle, Paris; contributes to purchase of Manet's *Olympia* for the French national collection

1890
Executes portrait commissions in America; receives commission for Boston Public Library murals, which occupy him until 1919

1891
Travels in Egypt, Greece and Turkey; elected Associate of National Academy of Design, New York

1893
Lady Agnew of Lochnaw (fig.23) at Royal Academy

1894
Elected Associate of the Royal Academy

1897
Full membership of Royal Academy and National Academy of Design

1898
Asher Wertheimer (fig.29) at Royal Academy, the first of twelve portraits of members of the Wertheimer family (executed up until 1908)

1900–14
Spends most summers in Alpine and Mediterranean holiday locations, devoting increasing attention to landscape and figure studies

1902
Lord Ribblesdale (fig.27), *The Ladies Alexandra, Mary and Theo Acheson* (fig.25), *The Misses Hunter* (fig.26), *The Duchess of Portland* and four other portraits at Royal Academy, consolidating Sargent's reputation as portraitist of the British upper classes

1903
First solo exhibition of informal work at Carfax Gallery, London

1905
First solo exhibition of watercolours at Carfax Gallery, London

1907
As American citizen, declines British knighthood

1911
Refuses to endorse Roger Fry's Post-Impressionist exhibition

1914
World War I breaks out while Sargent is on a painting trip in the Austrian Tyrol

1916
Receives first commission for murals at Boston Museum of Fine Arts; with second commission (1921) this occupies Sargent until 1925; sells *Madame Gautreau* (retitled *Madame X*, fig.15) to the Metropolitan Museum of Art, New York

1918
Visits French battlefront as Official War Artist

1919
Gassed (fig.57) at the Royal Academy

1925
Dies in Tite Street, London, 15 April

1925–6
Memorial exhibitions at the Royal Academy, London; Metropolitan Museum of Art, New York; Museum of Fine Arts, Boston

1926
Opening of 'Sargent Room' at the Tate Gallery, London, with display of nine of the Wertheimer portraits (controversial and soon dispersed); Roger Fry publishes a critical account of Sargent's work in *Transformations*

Select Bibliography

Kathleen Adler, 'John Singer Sargent's Portraits of the Wertheimer Family' in Linda Nochlin and Tamar Garb (eds.), *The Jew in the Text*, London 1995

Anonymous, 'America in Europe', *Magazine of Art* vol.6, 1882–3, pp.1–7

Charles Baudelaire, 'In Praise of Cosmetics' (1863), in Jonathan Mayne (trans. and ed.), *The Painter of Modern Life and Other Essays*, New York 1964

Max Beerbohm, 'A Defence of Cosmetics' (1894), reprinted in Karl Beckson (ed.), *Aesthetes and Decadents of the 1890s: An Anthology of British Poetry and Prose*, Chicago 1981

Charles Blanc, *Grammaire des arts du dessin*, Paris 1867

Albert Boime, 'Sargent in Paris and London: A Portrait of the Artist as Dorian Gray', in Patricia Hills and others, *John Singer Sargent*, exh. cat., Whitney Museum of American Art, New York 1987

Paul Bourget, *Outre-mer (Notes sur l'Amérique)*, Paris 1895

Richard Brilliant, *Portraiture*, London 1991

Sarah Burns, *Inventing the Modern Artist: Art and Culture in Gilded Age America*, New Haven and London 1996

David Cannadine, *The Decline and Fall of the British Aristocracy*, New Haven and London 1990

Evan Charteris, *John Sargent*, London 1927

John Collier, *The Art of Portrait Painting*, London 1910

R.G. Collingwood, *The Principles of Art*, Oxford 1938

Mary Cowling, *The Artist as Anthropologist: The Representation of Type and Character in Victorian Art*, Cambridge 1989

Leonore Davidoff, *The Best Circles: Society Etiquette and the Season*, London 1973

Nancy W. Ellenberger, 'The Souls and London "Society" at the End of the Nineteenth Century', *Victorian Studies*, vol.25, Winter 1982, pp.133–60

Havelock Ellis, 'Spanish Dancing', *The Soul of Spain*, London 1929

Trevor Fairbrother, *John Singer Sargent*, New York 1994

Roger Fry, 'J.S. Sargent as Seen at the Royal Academy Exhibition of His Works, 1926, and in the National Gallery', *Transformations*, London 1926

—— 'Royal Academy', *The Pilot*, 12 May 1900

Paula Gillett, *The Victorian Painter's World*, Gloucester 1990 (published in the USA as *Worlds of Art*)

James Hamilton, *The Misses Vickers: The Centenary of the Painting by John Singer Sargent*, exh. cat., Mappin Art Gallery, Sheffield 1984

Henry James, 'John S. Sargent' (first published in *Harper's New Monthly Magazine*, October 1887), reprinted in John L. Sweeney (ed.), *The Painter's Eye*, Madison, Wisconsin 1989

—— *The Letters of Henry James*, selected and ed. Percy Lubbock, London 1920

William James, *Principles of Psychology*, 1890; chapters reprinted in G.H. Bird (ed.), *Selected Writings*, 1995

Vernon Lee (pseudonym of Violet Paget), *Vernon Lee's Letters*, ed. Irene Cooper-Willis, London 1937

George Dunlop Leslie, *The Inner Life of the Royal Academy*, London 1914

Patricia Mainardi, *The End of the Salon: Art and the State in the Early Third Republic*, Cambridge 1993

Henry Stacy Marks, *Pen and Pencil Sketches*, 2 vols., London 1894

Robert de Montesquiou, 'Le pavé rouge: quelques réflexions sur "l'oeuvre" de M. Sargent', *Les Arts de la vie*, June 1905

George Moore, 'A Portrait by Mr. Sargent' (1893), reprinted in *Modern Painting*, London 1898

Linda Nochlin, 'Impressionist Portraits and the Construction of Modern Identity', in Colin B. Bailey (ed.), *Renoir's Portraits: Impressions of an Age*, exh. cat., National Gallery of Canada, Ottawa 1997

Richard Ormond, *John Singer Sargent: Paintings, Drawings, Watercolours*, London 1970

Harold Perkin, *The Rise of Professional Society: England Since 1880*, London and New York 1989

Claude Phillips, *Emotion in Art*, London 1925

Carter Ratcliff, *John Singer Sargent*, Oxford 1983

W. Graham Robertson, *Time Was*, London 1931

Julia Rayer Rolfe and others, *The Portrait of a Lady: Sargent and Lady Agnew*, exh. cat., National Gallery of Scotland, Edinburgh 1997

Walter Richard Sickert, 'Sargentolatry' (1910), reprinted in Osbert Sitwell (ed.), *A Free House!: Or The Artist as Craftsman*, London 1947

Georg Simmel, 'Sociability' (1910), reprinted in Donald N. Levine (ed.), *On Individuality and Social Forms*, Chicago and London 1971

Marc Simpson and others, *Uncanny Spectacle: The Public Career of the Young John Singer Sargent*, exh. cat., Sterling and Francine Clark Art Institute, Williamstown, Massachusetts 1997

R.A.M. Stevenson, 'J.S. Sargent', *Art Journal*, March 1888, pp.65–9

—— *The Art of Velasquez*, London 1895

Thorstein Veblen, *The Theory of the Leisure Class: An Economic Study of Institutions*, London 1899

Mary Crawford Volk and others, *John Singer Sargent's El Jaleo*, exh. cat., National Gallery of Art, Washington, D.C. 1992

James McNeill Whistler, 'Mr. Whistler's "Ten O'Clock"' (1885), reprinted in J.M. Whistler, *The Gentle Art of Making Enemies*, Dover paperback 1967

Index

Credits

Copyright Credits

Photographic Credits